Remembering

Long Island

Joe Czachowski

TURNER

PUBLISHING COMPANY

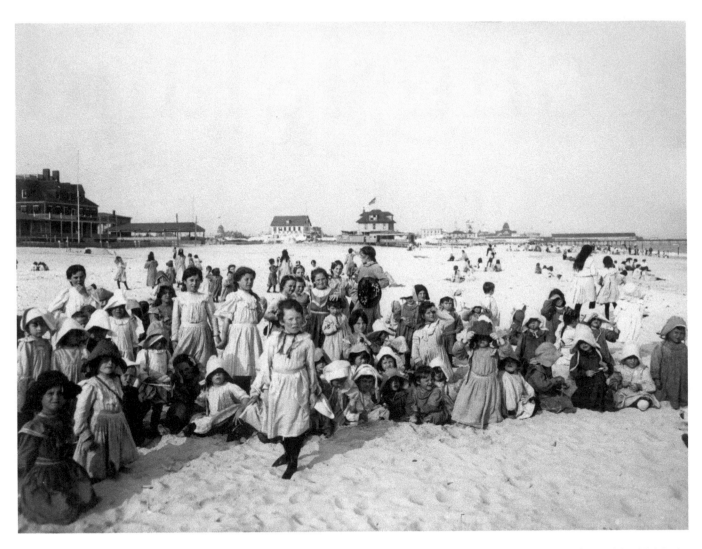

Young ladies are dressed properly for the beach on Rockaway around 1903. While sea air and salt water were deemed healthful, the sun was not.

Remembering

Long Island

Turner Publishing Company
4507 Charlotte Avenue, Suite 100
Nashville, TN 37209
Phone: (615)255-2665 Fax: (615)255-5081

Remembering Long Island

www.turnerpublishing.com

Library of Congress Control Number: 2010932636

ISBN: 978-1-59652-710-2
ISBN-13: 978-1-68336-850-2 (hc)

Printed in the United States of America

CONTENTS

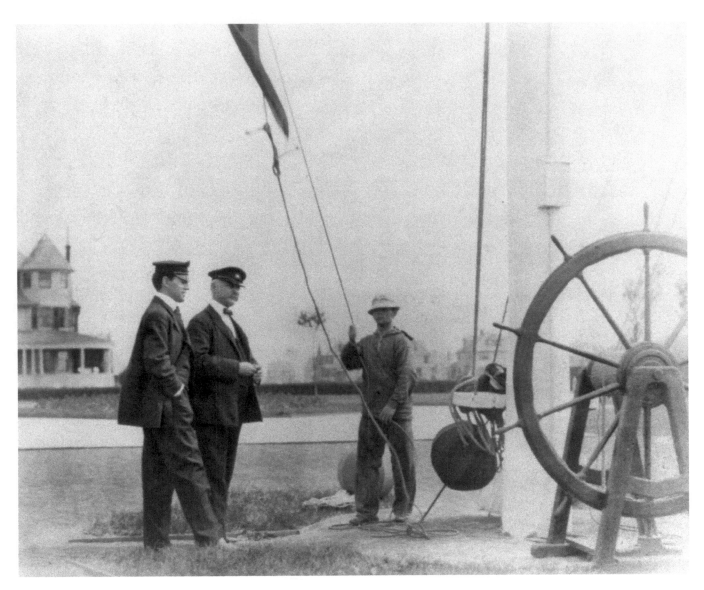

A flag is hoisted up a sturdy pole at the Long Island Yacht Club in 1905. Oyster Bay was one of several homes for the club through the years. Others included New York City; Mystic, Connecticut; and Hoboken, New Jersey. To paraphrase financier J. P. Morgan, the club's commodore from 1897 to 1899, if you had to ask how much a yacht cost, you probably couldn't afford one. Lucy Carnegie became the first female member in 1894.

Acknowledgments

This volume, *Remembering Long Island,* is the result of the cooperation and efforts of many individuals, organizations, and corporations. It is with great thanks that we acknowledge the valuable contribution of the following for their generous support:

The Brooklyn Historical Society
Freeport Memorial Library
Library of Congress
New York State Archives

Our pets become an integral part of our lives. My cat certainly was. Her wry smile and wise eyes were a comfort in bad times. I will miss her most while doing this; she loved walking on the keyboard.

———————

With the exception of touching up imperfections that have accrued with the passage of time and cropping where necessary, no changes have been made. The focus and clarity of many images are limited to the technology and the ability of the photographer at the time they were recorded.

PREFACE

What's in a name? In the case of Long Island, both words are key. Long Island is long—118 miles. Its widest distance is 23 miles. And it is an island, the largest in the continental United States. Long Island comprises four counties, two that are boroughs of New York City (Queens and Brooklyn) and two that contain suburbs of the city (Nassau and Suffolk). This collection of historic images reflects all four, including sectors of Long Island that are now deep within the borders of New York City. Amazingly, Long Island hasn't sunk under the weight of its nearly eight million people. Though it is part of New York State, that hasn't stopped some from suggesting it should be the fifty-first state of the Union. It certainly has everything to thrive and survive on its own: industry, agriculture, natural beauty, and its most important attribute, its inhabitants.

As is emphasized by town names like Matinecock, Massapequa, and Quogue, American Indians inhabited the Island when the European colonists first arrived, and their impact on its culture has been lasting. The Dutch were among the Island's earliest settlers, spreading out from the growing town on the smaller island of Manhattan, while New England Puritans crossed Long Island Sound from Connecticut and Massachusetts. All embodied those "Yankee" ideals marked by hard work and religious conviction.

The British eventually dominated on Long Island, commanding trade and settlement. The farmland was rich and the sea was plentiful, with bountiful harvests of things common and exotic, potatoes and oysters. With sheltered harbors available, shipping became dominant both for building and for commerce. The area was settled slowly, and those who wanted a change and challenge found it a paradise. As was the case with other profitable colonies, people on Long Island had divided loyalties, and when the first shots were fired in the Revolutionary War, rebel and loyalist were firmly entrenched.

Commander George Washington had the Declaration of Independence read aloud to his troops on Long Island in that famous July of 1776. A defining battle erupted on the Island a month later. England won that round and retained the Island for the balance of the war, but the colonial militias learned how to fight

delaying actions and secure proper retreats, which bode well for later battles. When the Revolution was won, loyalists left for points north, and Long Island went about growing and becoming stronger as an important part of New York State.

New York City in the nineteenth century was the center of American commerce. The wealthy and powerful of the Gilded Age—names such as Morgan, Vanderbilt, and Roosevelt—began to see Long Island as a place to escape the grime of the city and to build lavish homes and estates. Nassau and Suffolk counties still boast some of the most expensive homes in the Northeast. Less affluent folk also began to appreciate Long Island's riches, and a constant flow of people and business expanded its population, a process accelerated by the railroads, which were shrinking distances between points on the Island.

At the turn of the century, with the influx of immigrants from Europe, the jump from Ellis Island to Long Island was inevitable as well as profitable. New life meant new business, new business meant more business, and more business meant more people. All forms of work were available—skilled and unskilled; shipping, farming, transportation—and with prosperity rising for many, something called leisure time entered the vocabulary, and Long Island's beaches, harbors, and forests were there to enjoy.

A relatively constant population growth continued throughout the succeeding decades up to World War II. Long Island went on a war footing in the 1940s and was a center for aviation technology, with the army, navy, and marines all having planes built there. When the war was over—and when most thought growth would be static—the modern suburb was born, and Long Island became its drawing board.

Taking advantage of the GI Bill, servicemen received an education, found profitable employment, and qualified for a mortgage. As varied businesses established bases for industry and technology on Long Island, the needed workforce was in place. Long Island grew from the 1950s to the 1990s, and while it did suffer some setbacks, tradition and an extremely strong sense of community permeate Long Island today.

Notables of Long Island have included Captain Kangaroo (Bob Keeshan), Billy Joel, and Walt Whitman. In the realm of fictional Long Island, the Hardy Boys, Frank and Joe, do their youthful sleuthing in Bayport; the shark in Peter Benchley's *Jaws* plies the waters off Long Island Sound; the Marx Brothers film *Animal Crackers* is set on Long Island; and, of course, Ray Romano's television family lives in Lynbrook.

—*Joe Czachowski*

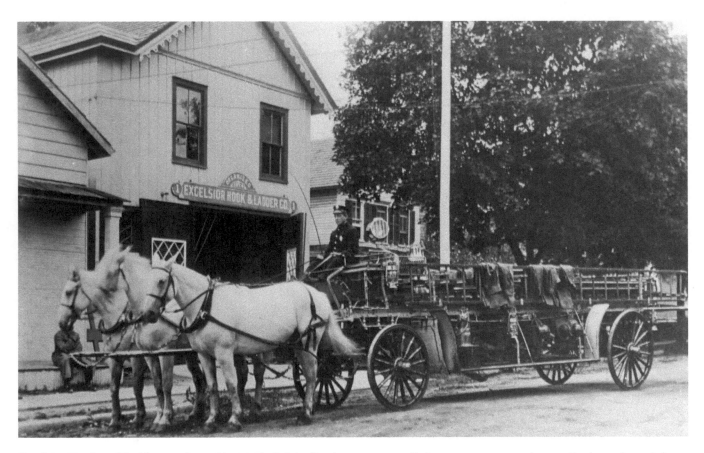

Excelsior Hook and Ladder was formed in 1874. Originally, the apparatus relied on manpower, not horses. Buckets adorned the sides and would be dropped into wells for filling. The Freeport Fire Station was also used as a voting place and meetinghouse. The photo is from the early 1900s.

Hard Work and Railroads

(1884–1899)

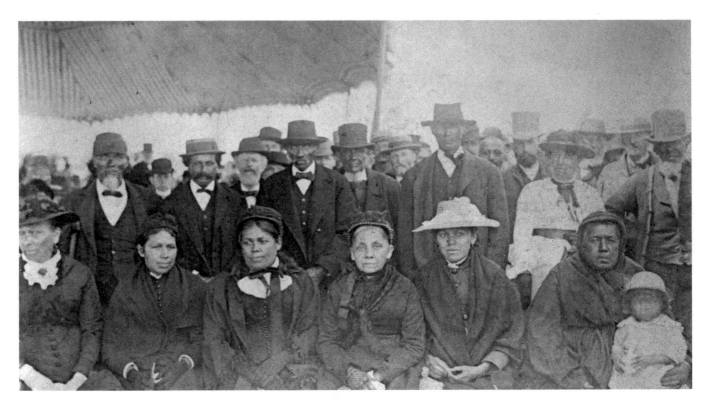

These Shinnecock Indians were photographed on their Southampton reservation in 1884. Descendants of the Algonquin tribe and, according to legend, named from a pattern on the back of a great turtle, the Shinnecocks lived on the shores of Long Island and hunted whales from dugout canoes. The Shinnecocks are one of the oldest self-governing tribes, with a tribal government that was recognized by the New York state legislature in 1792. From their dress, we can infer the impact of "civilizing" programs by the 1880s.

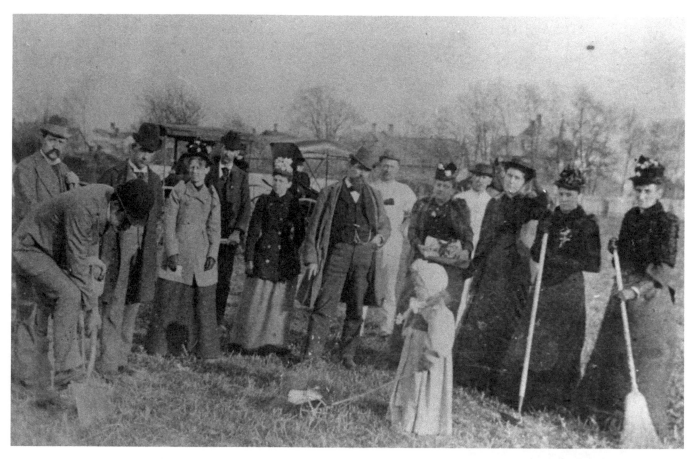

Here is the ground-breaking ceremony for the Grove Street School in Freeport in 1893. Perhaps the little girl in front is a prospective student. The Freeport Public Library was started by the school's principal, and for a time the library's books were kept in his office clothes closet.

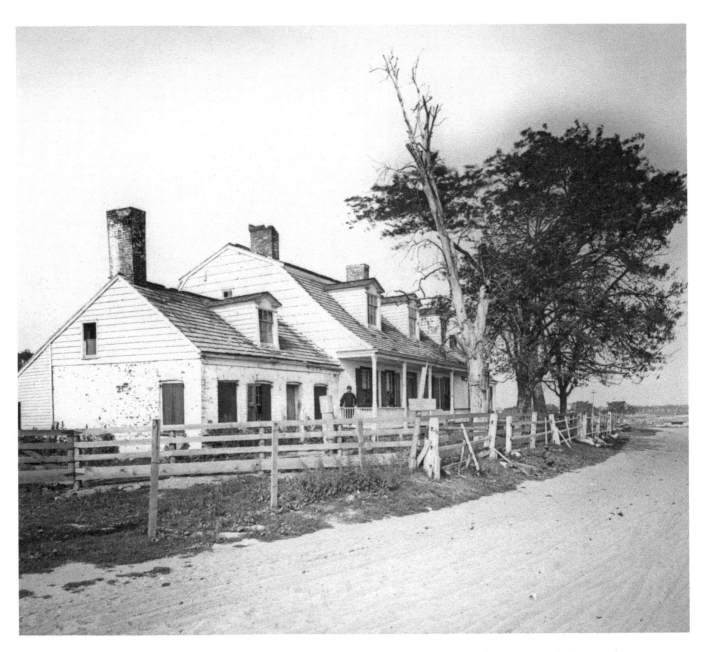

Seen here in the late 1800s, this house was in Bay Ridge in an area close to where the Revolutionary War's first significant engagement, the Battle of Long Island (also known as the Battle of Brooklyn) was fought in August 1776.

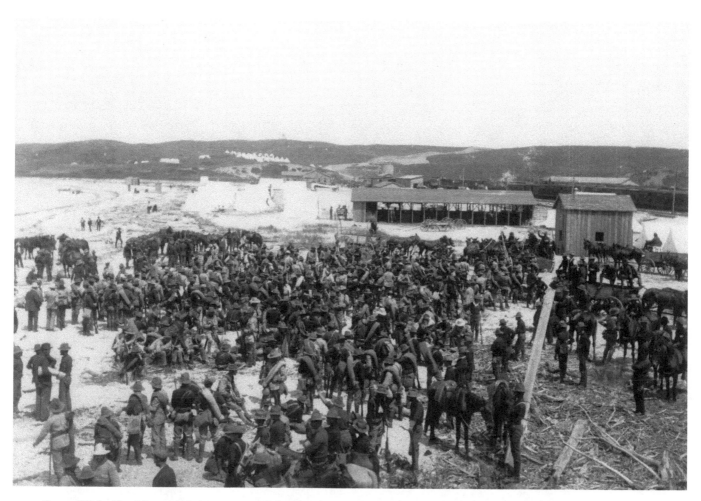

Camp Wickoff at Montauk Point was established as a base where soldiers returning from the Spanish-American War could be quarantined and recuperate from any tropical diseases they might have contracted in Cuba. This 1898 photo shows Colonel Theodore Roosevelt's Rough Riders arriving. Initially conditions at the camp fell short of expectations, prompting President William McKInley to set up a commission to expedite a cleanup. More than 20,000 soldiers disembarked there before its closure.

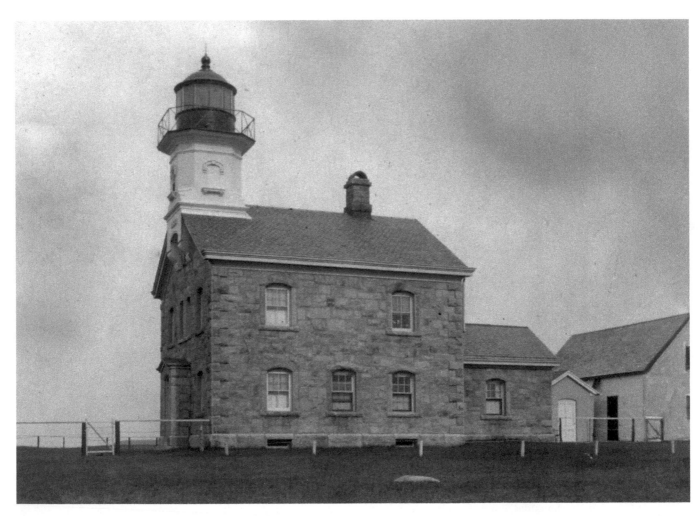

The Old Field Point Light guards the entrance to Port Jefferson Harbor. Seen here around the turn of the century, the station was established in 1823 and the light first activated in 1868. Edward Shoemaker was the light's first keeper. The dwelling was also used as a town hall and town offices, and was originally a wood tower on a granite house. It was automated in 1933.

Autos and Airplanes

(1900–1939)

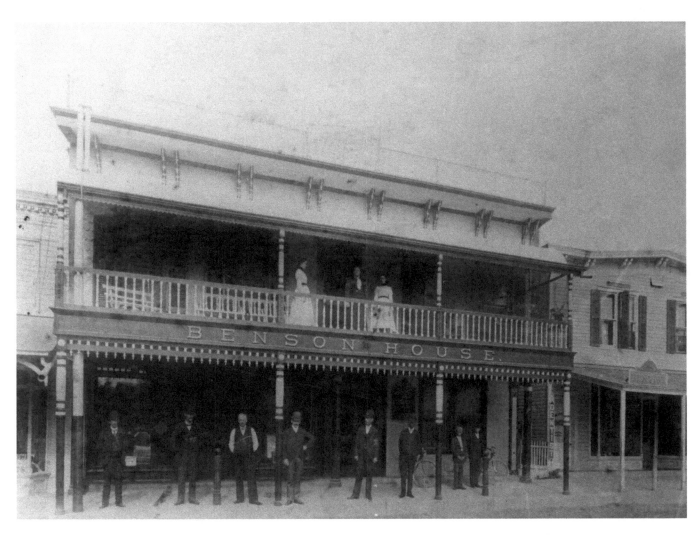

The Benson House, photographed in 1902, was a commercial travelers' hotel on South Main Street in Freeport. It appears to be quite spiffy and even has female lodgers on the second floor. It was probably a welcome relief from long, tedious travel on Long Island's early roads.

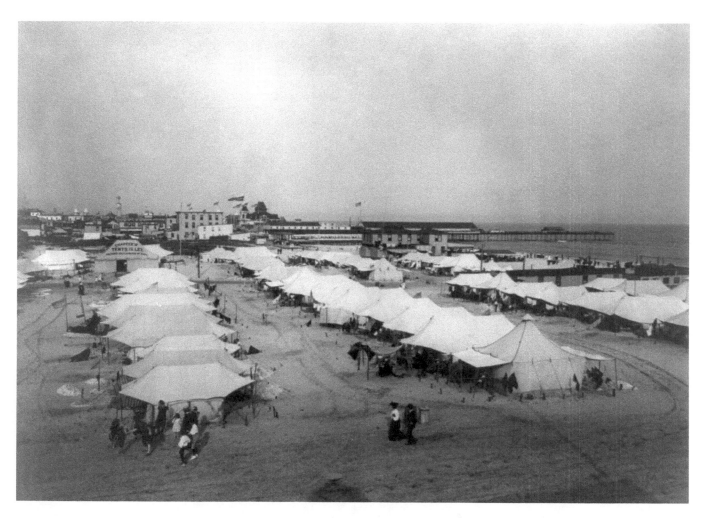

This tent city at Rockaway around 1903 is most likely the setting for a religious revival, popular during the era. In the background are hotels, amusements, and a long fishing pier. During the summer the beach towns came alive.

The youngest child of Theodore and Edith Roosevelt, Quentin Roosevelt is seen here at the family home in Sagamore Hill in November 1904, shortly before his seventh birthday. A pilot in the Army Air Service during World War I, he was killed in an aerial battle behind German lines. An airfield outside Garden City was renamed Roosevelt Field in his honor, and it was from that field that Charles Lindbergh would take off on his historic transatlantic flight in 1927.

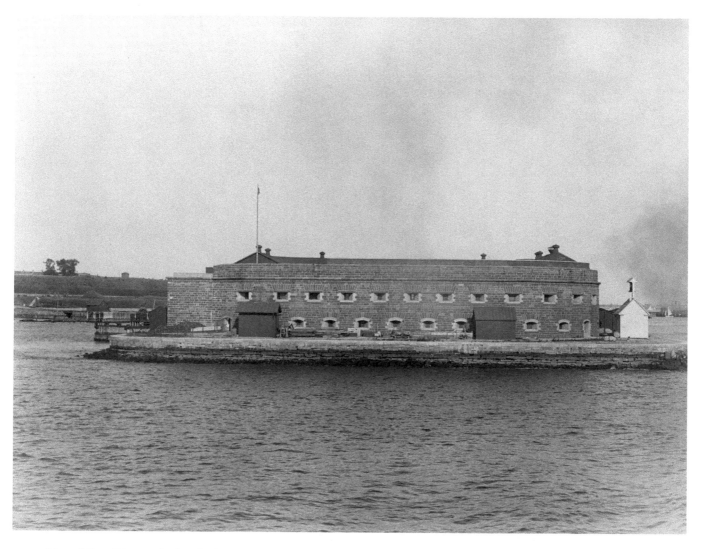

Named Fort Diamond when built in 1822, Fort Lafayette was renamed for the French military officer of Revolutionary War fame. Seen here around 1904, the fort was located between Long Island and Staten Island. Its good view of the channel into New York Harbor gave it strategic value. The fort housed Confederate prisoners during the Civil War. It fell into disrepair and eventually was razed to become one of the "feet" for the Verrazano-Narrows Bridge in 1960.

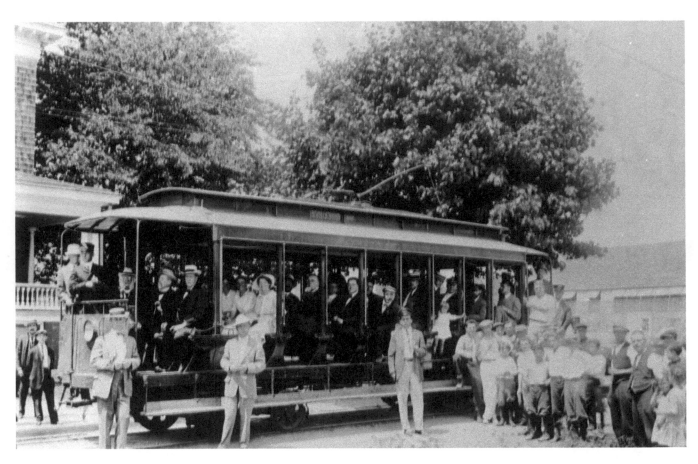

The Grove Street Trolley, photographed around 1908, was operated by the Long Island Traction Corporation. This Freeport route was called the "Fisherman's Delight" because it ran along Grove Street to Front Street and down to the docks at the foot of Woodcleft Channel. The line was shut down around 1923.

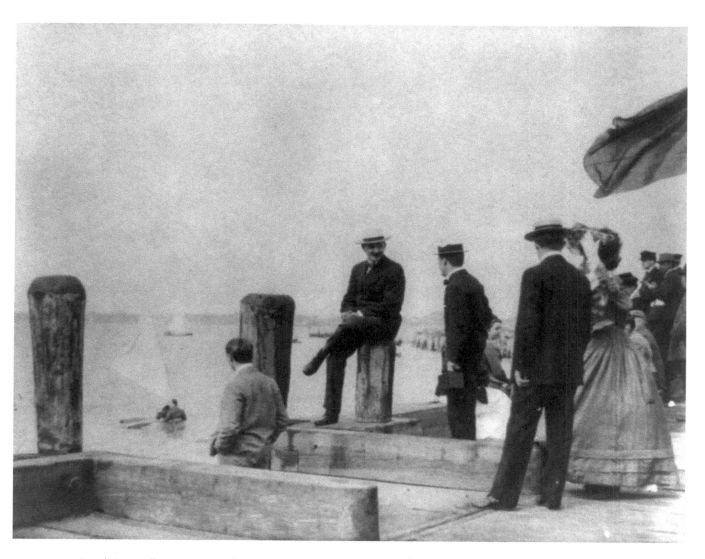

People in small sailboats dot the cove of Oyster Bay in 1905 while stylishly attired members of the upper class wait for transportation to a party aboard a luxurious yacht anchored in the harbor.

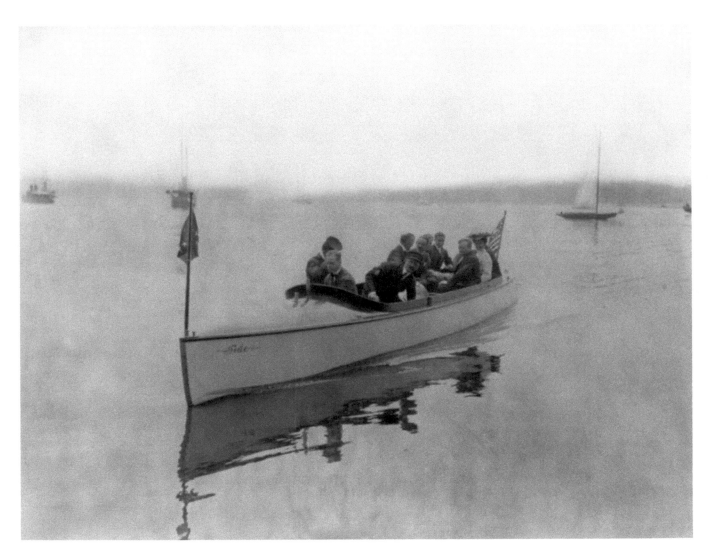

A motor launch ferries several of the well-heeled to their destination on the calm waters of Oyster Bay in 1905.

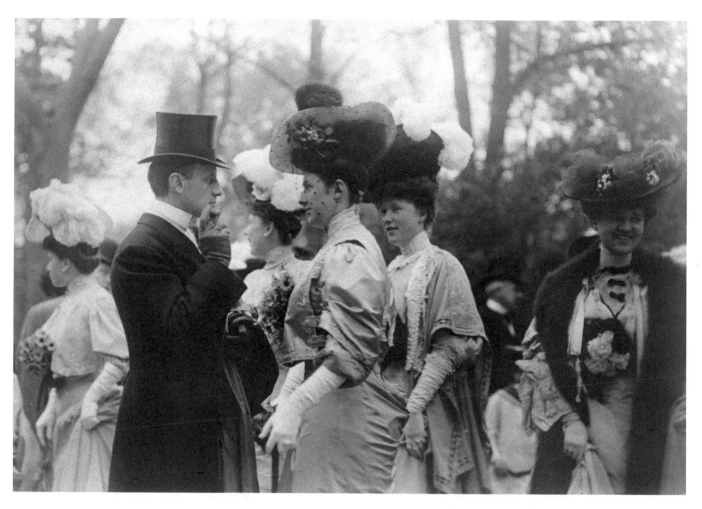

Mr. and Mrs. Goodhue Livingston and Mrs. Alfred Gwynne Vanderbilt are among the fashionable set gathered at Montauk in May 1906 for the coaching club's parade. Livingston was the architect who designed the famous St. Regis Hotel in New York City. Mrs. Vanderbilt's father was Captain Isaac Emerson who owned the company that produced Bromo-Seltzer. Alfred Vanderbilt would die a hero aboard the ocean liner *Lusitania*.

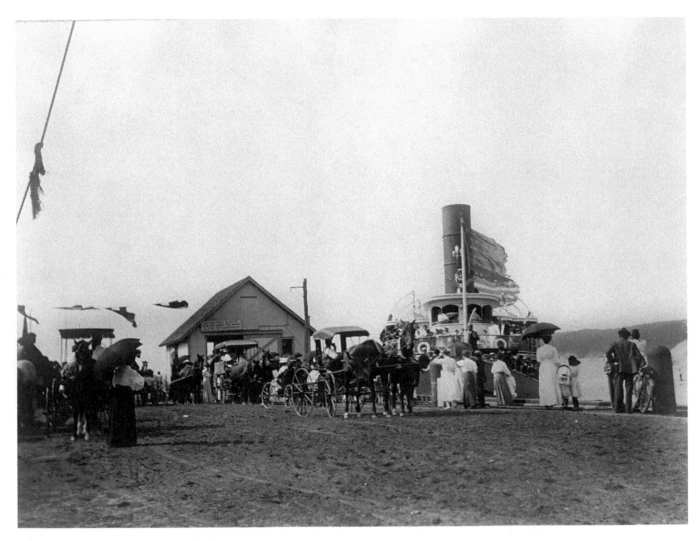

This scene is at the steamboat dock in Port Jefferson in August 1908. In the background is the legendary ferry *Park City*, which plied the waters year-round between Port Jefferson and Bridgeport, Connecticut, starting in 1883. The ferry was the brainchild of P. T. Barnum, who saw success transporting mostly vacationers back and forth. The *Park City* was built on the Island at the famed Mather Shipyard.

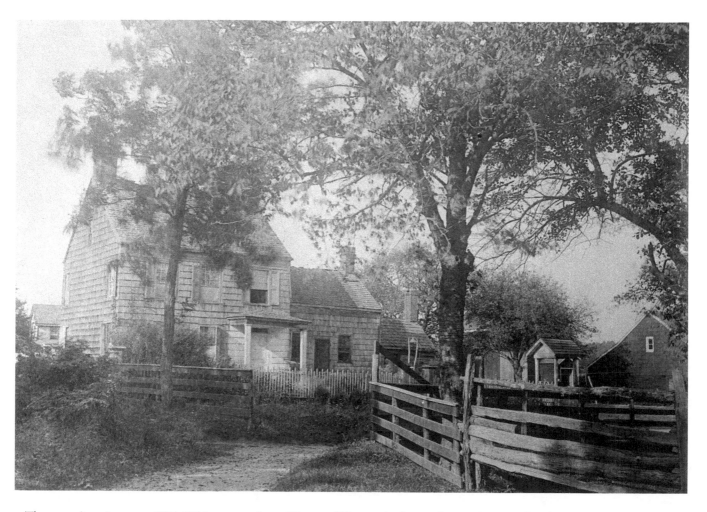

The great American poet Walt Whitman, author of *Leaves of Grass* and other works, was born in this three-section house on May 31, 1819, and lived here the first four years of his life. Located in West Hills, south of Huntington, the house is seen here before 1910, the year a fire destroyed the third section at right.

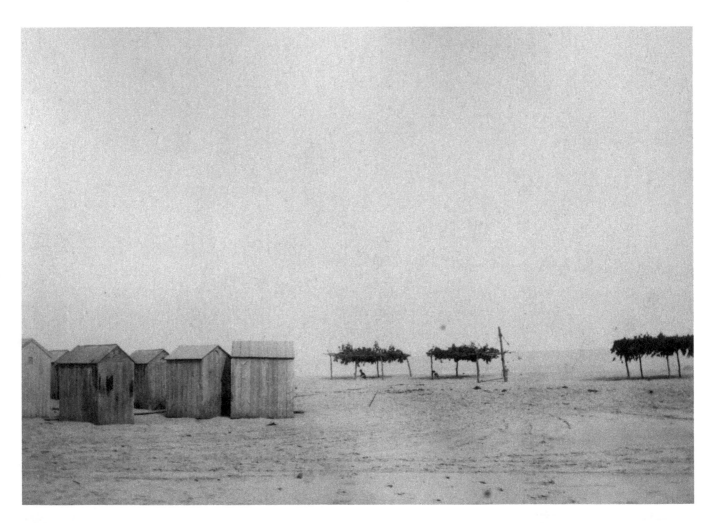

With the small beach houses for changing still clustered together in this early 1900s view, it appears the summer season at East Hampton has not yet arrived. The shaded areas along the beach will provide relief from the sun when the time comes.

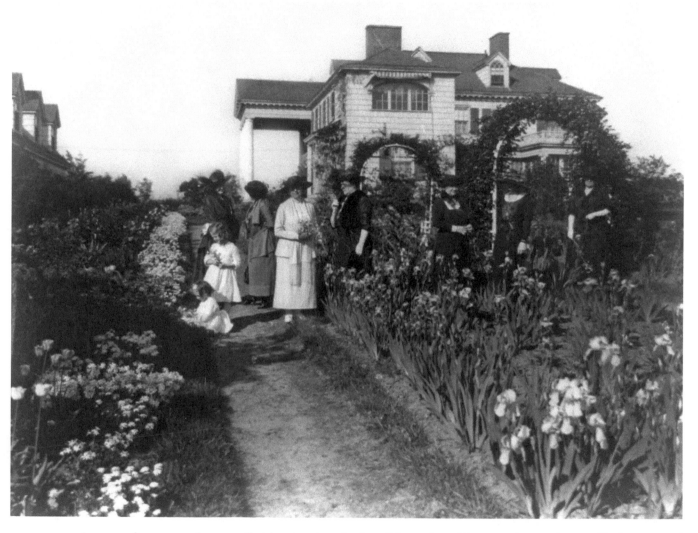

A group of women and two small girls enjoy the splendor of the garden of Frances Johnston Paris in Flushing around 1910. The wife of John W. Paris, she was an activist for social causes and woman suffrage. She lobbied for expanded women's employment opportunities, and for day nurseries for women who did find employment. She belonged to the Good Citizenship League of Flushing.

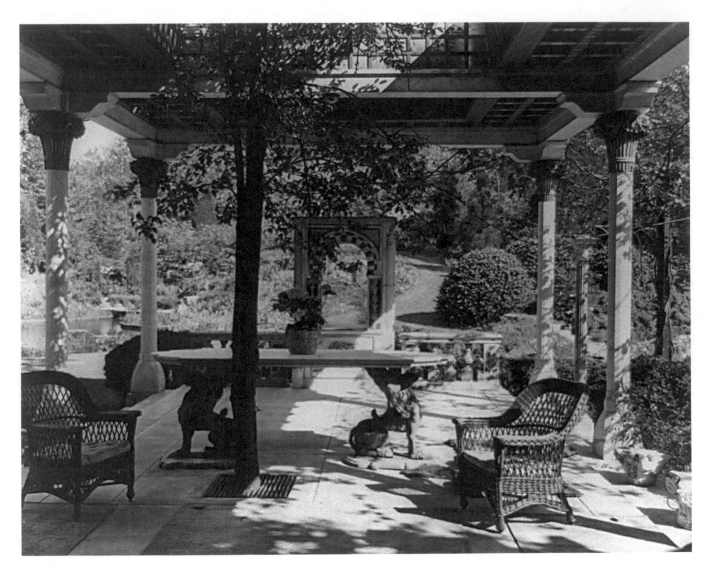

Photographed in 1911, this outdoor room at Laurelton Hall in Cold Spring Harbor was designed by the estate's owner, the designer and artist Louis Comfort Tiffany. In 1918 Tiffany, whose father founded Tiffany and Company, dedicated 60 acres of Laurelton Hall to foster growth in the arts. He felt a summer retreat providing uninterrupted enjoyment of nature would nurture the creative process. Tiffany died in 1933, and the focus of the foundation he established was later changed to funding grants for the arts.

Forest Park, a wooded region with hilltop views of Long Island Sound, was established in Queens in 1898 with a central drive designed by the famous landscape architect Frederick Law Olmsted. That year bandleader George Seuffert, Sr., gave the first of his many free concerts at the park. The bandstand seen here in 1910, possibly with Seuffert and his band performing, was replaced in 1920 by a bandshell now named for him. In later years his son, George Seuffert, Jr., would continue the Sunday afternoon music tradition.

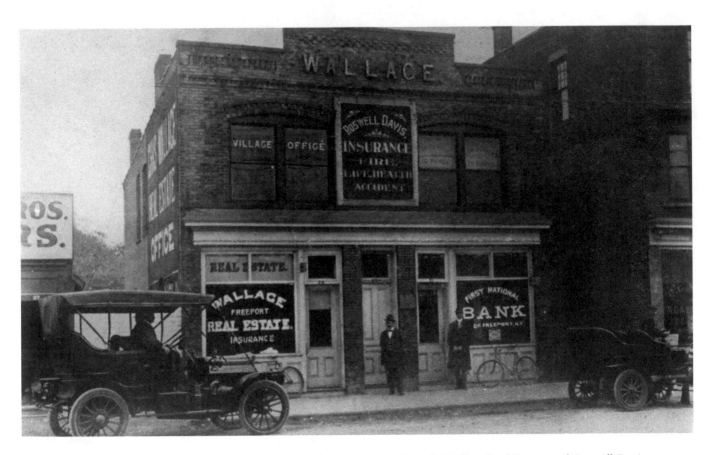

The Wallace Building housed the Freeport Village office, the First National Bank, Wallace Real Estate, and Roswell Davis Insurance. Rents in the building ran to $15 a month (including light and heat), a tidy income for the owner.

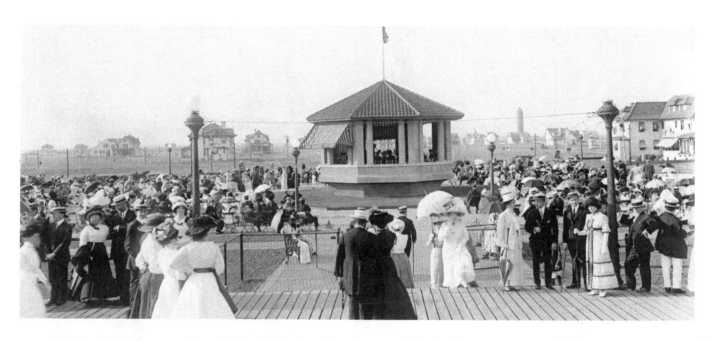

Well-dressed spectators gather at Music Park in Long Beach in 1911. The bandstand and music pavilion were near the Hotel Nassau and undoubtedly provided entertainment for guests. The stand was gone by the early 1920s, however, to make way for the Castle by the Sea Baths and a theater.

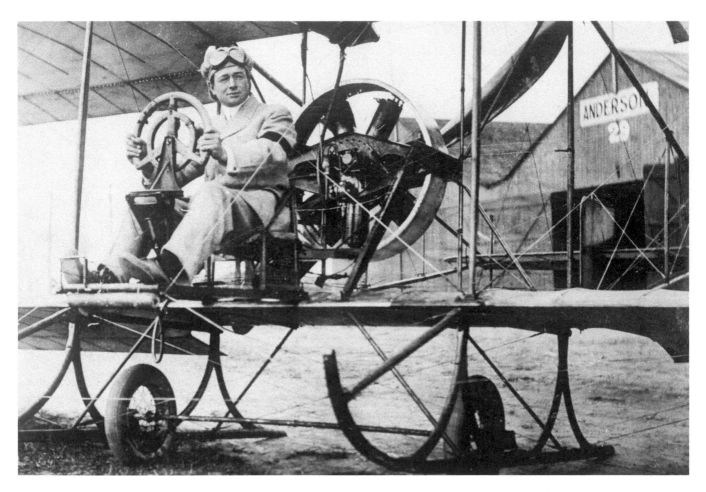

The first U.S. authorized airmail runs were made from Garden City to Mineola during an aviation meet in September 1911. The honor of serving as pilot for the first delivery was given to Paul Peck. Seated at the controls in his "gyro type" airplane, Peck is seen here in Mineola in 1911, almost certainly on or near the occasion of his historic flight.

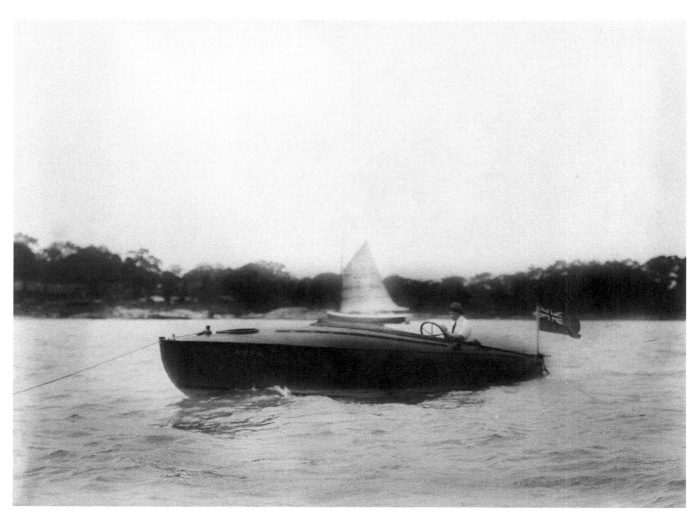

In 1912 Huntington hosted the Harmsworth Cup motor boat race, with contestants hoping to best the fastest time recorded in a U.S. race the previous year—40.4 miles per hour. England's Royal Motor Yacht club sent two boats, *Maple Leaf IV* and *Mona*. *Maple Leaf IV* carried home the trophy, but *Mona* broke an oil pipe and caught fire, the *New York Times* reported, and failed to finish the race. The ailing *Mona* is seen here.

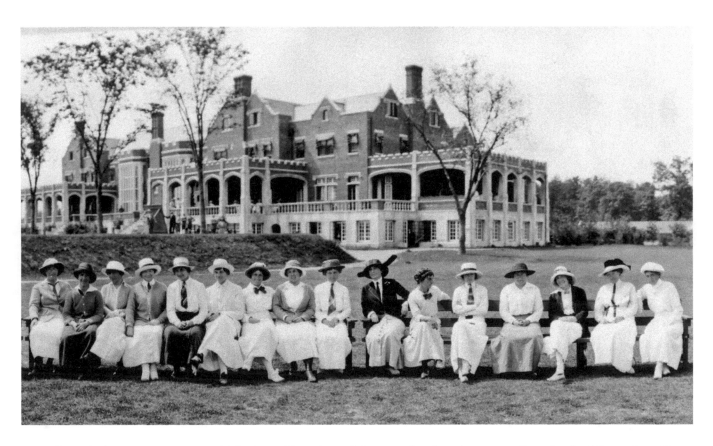

As a rule in the late 1800s, women couldn't play golf at private clubs on weekends and were not allowed to be full members. Signs would read "Gentlemen only, ladies forbidden." But that began to change, and the Nassau Country Club opened its course in 1899. Participants in the Women's Metropolitan Golf Championship at the Nassau Country Club pose here in 1913. Women who played the course through the years included Nona Barlow, Fanny C. Osgood, and Marion Hollins.

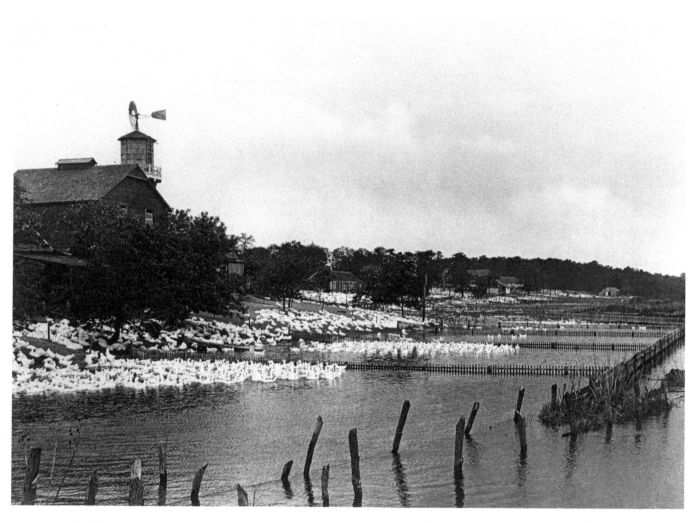

At this duck farm photographed in Speonk in 1914, rectangular pens separate the ducks on land and in the water. The vast enterprise includes barns, sheds, and a water tower.

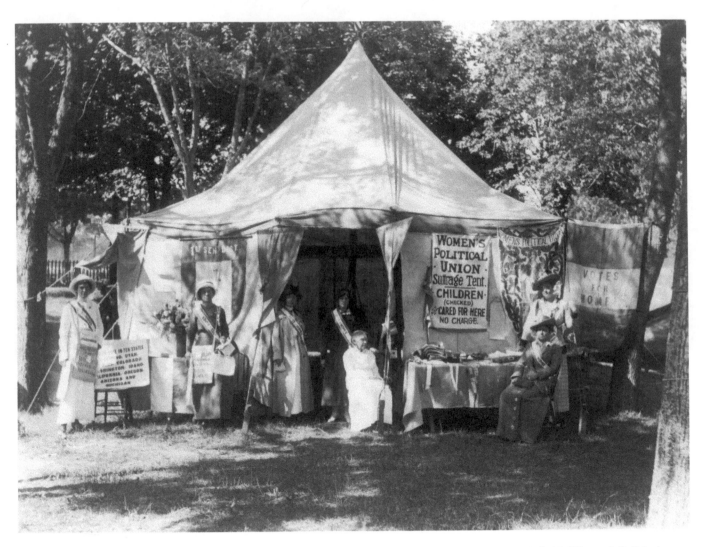

Harriet Stanton Blatch and Carrie Chapman Catt, leaders of the woman suffrage movement, occupied this Women's Political Union tent at the 1914 Suffolk County Fair. To collect signatures for a petition to put woman suffrage on the state ballot in 1915, they embarked on an Empire State tour that started with a summer tour of southern New York. Free child care was offered at the rallies.

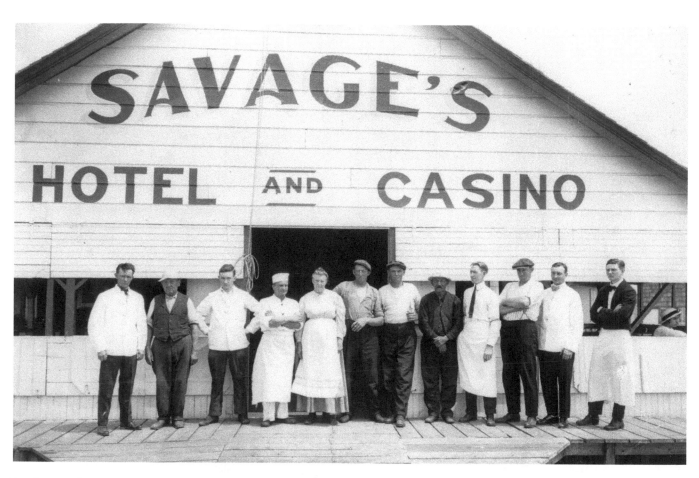

Employees of Savage's Hotel and Casino in High Hill Beach pose in 1915. Open from May to October, the hotel was a well-known establishment with a private beach, large dance hall, baseball field, and 40 rooms facing the ocean. Savage's also had a colony of bungalows and cottages for rent. With gaming offered in the casino, Savage's was considered a "sportsman's paradise."

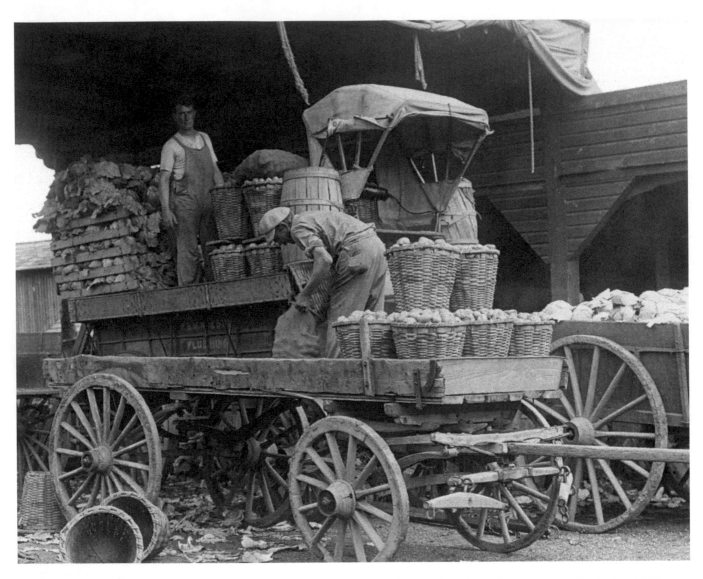

At a truck farm near Jamaica, Queens, two men ready a wagonload of potatoes and cabbages for transport and sale. In 1916 large fields were still producing harvests of crops to be brought to market and sold by the side of the road. Hard, honorable work could be found.

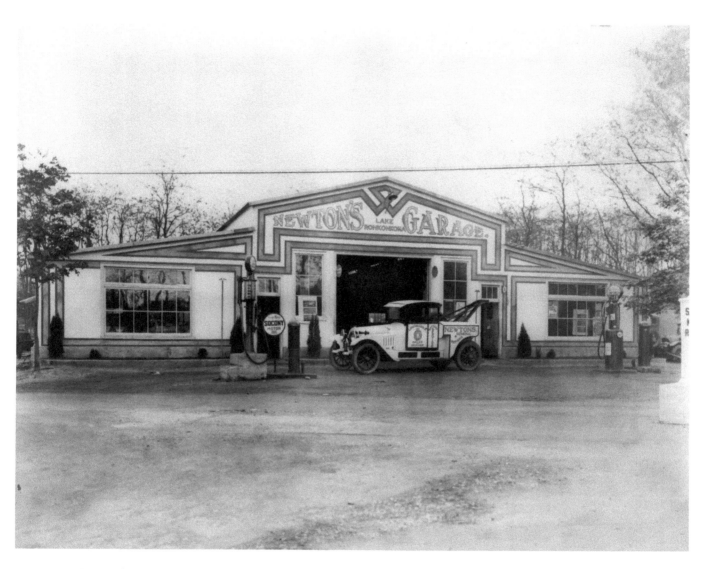

Newton's Garage at Rank Avenue and Portion Road in Lake Ronkonkoma, with its modern gas pumps and tow truck, serviced automobiles in this summer resort town. Ronkonkoma is Long Island's largest freshwater lake. According to popular legend, the lake, formed by a retreating glacier, is bottomless. After the turn of the century, fashionable lakefront dwellings began to dot the area.

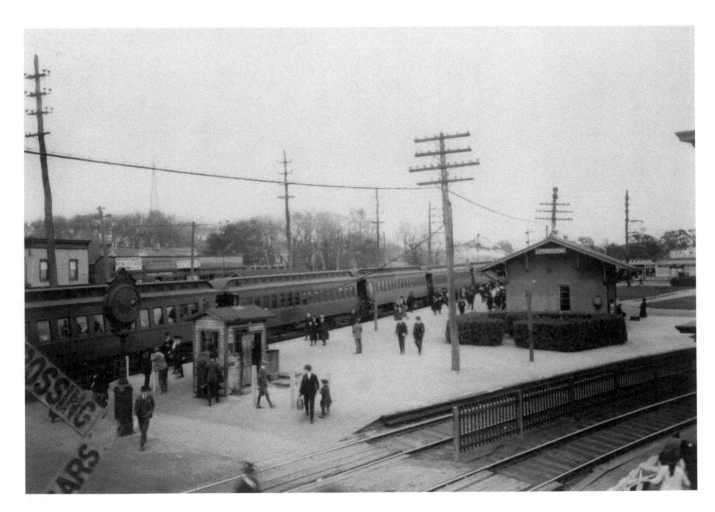

The Lynbrook station of the LIRR isn't quite bustling yet in this scene from around 1915. A fair number of people were commuting by then, but ridership would grow exponentially through the remainder of the century. Routes continued to be established throughout the Island with the final destination being New York City.

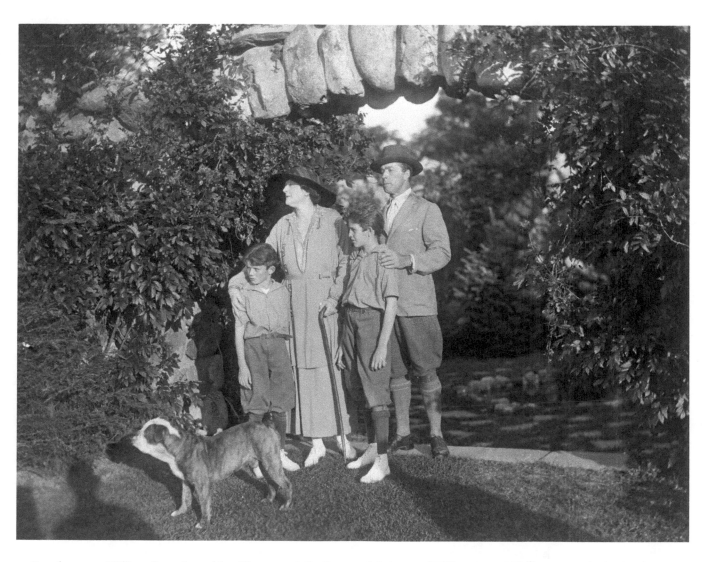

Broadway star William Faversham; his wife, actress Julie Opp; and their sons, William Jr. and Philip pose with the family pup at the entrance to Huntington's Rosemary Open Air Theatre. The theatrical family was on hand to help with a national pageant put on by the Red Cross on October 5, 1917, to raise funds for overseas victims of the war.

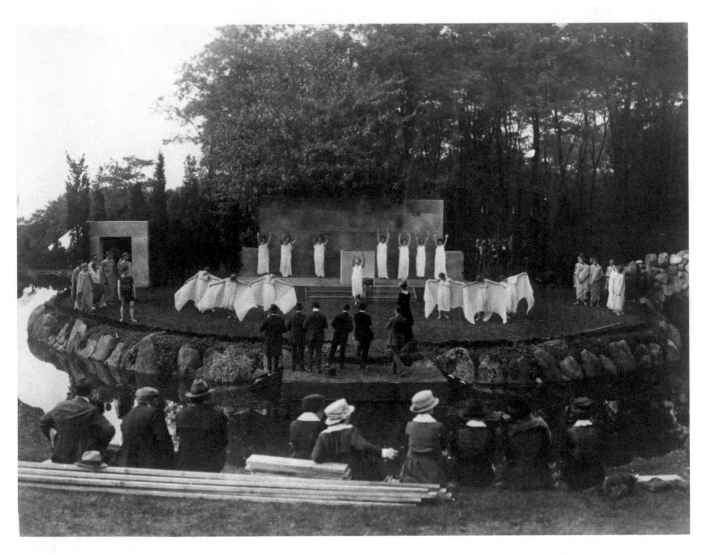

A small crowd watches morning rehearsal for the National Red Cross Pageant of October 5, 1917. Later that day, 5,000 people attended the show to see the likes of John and Ethel Barrymore, Clifton Webb, Tyrone Power, and even New York's famed Fighting 69th Division. The orchestra was hidden in the trees on the estate of financier Roland B. Conklin. The event raised $50,000.

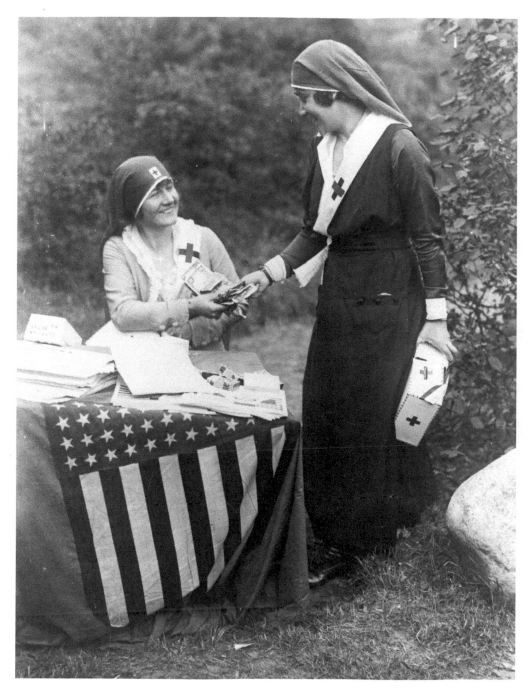

Actresses Frances Starr and Bijou Fernandez display a portion of the $50,000 raised at the National Red Cross Pageant in Huntington. Both were well-known veterans of the theater, Fernandez having reportedly debuted onstage at the age of three.

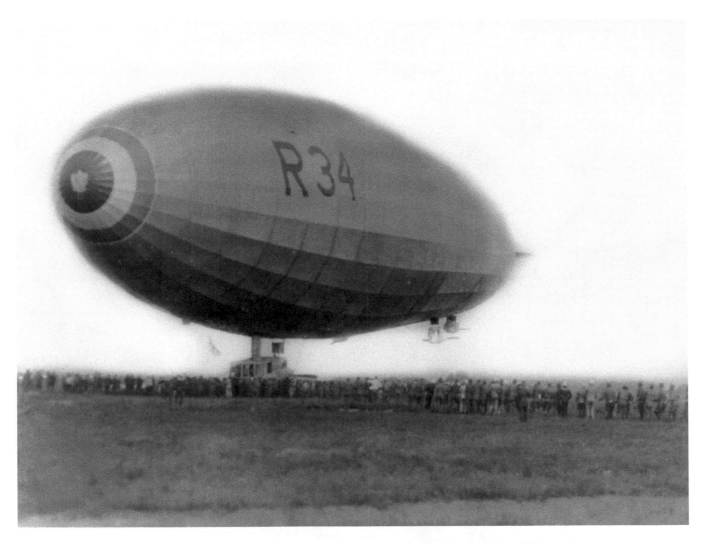

British dirigible R-34 is shown touching down in Mineola on July 6, 1919, after the first transatlantic crossing of an airship. The landing was a short stop for regassing, refueling, and reballasting since there were no hangars on the East Coast able to house the huge ship—it was 640 feet long, 79 feet wide, and 92 feet high. The R-34 had five motors and five cars that carried 30 people. Germany, negotiating the Versailles Treaty at the time, was upset with the publicity of the crossing.

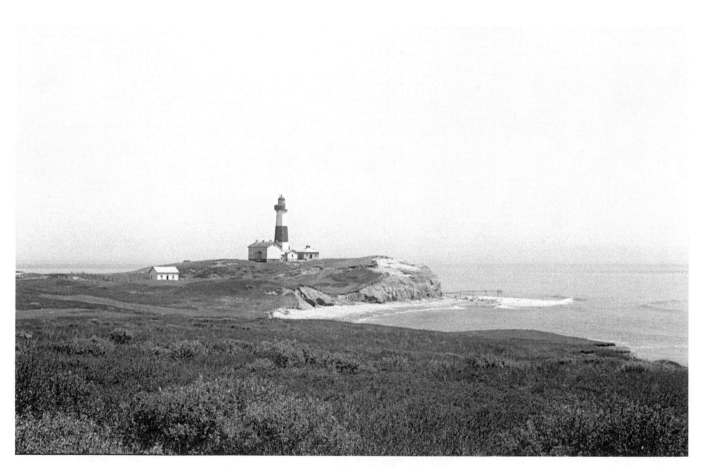

This picturesque 1919 view shows the famous Montauk Lighthouse at the tip of Long Island on the eastern shore. The first lighthouse in New York, it was authorized by Congress in 1792, during George Washington's administration, and constructed four years later. Still active today, the lighthouse stands where Block Island Sound meets the open Atlantic.

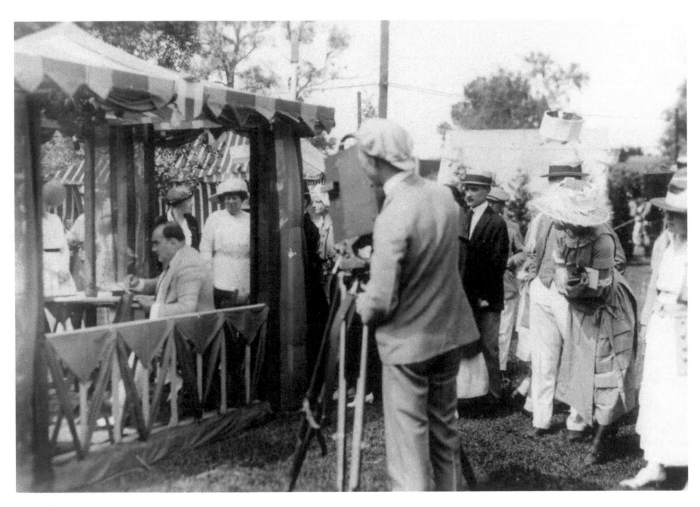

Renowned for his dramatic opera voice, Enrico Caruso, seated at left, is shown drawing sketches for people at a Southampton charity fair in August 1920. Caruso was a pioneer in the recording industry, promoting the phonograph and making recordings as early as 1902. His vocal accomplishments need no lavish descriptions; he is widely considered the greatest and most influential tenor of the twentieth century.

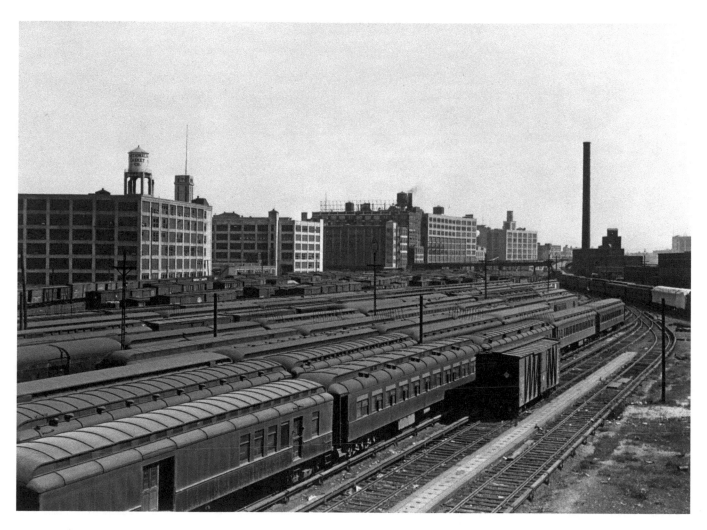

The number of trains and factories visible in this view of Long Island City suggests the area's commercial strength in 1922. Formed of four small communities in 1870, Long Island City became part of New York City in 1898 and grew by virtue of its advantageous location across the East River from Manhattan. The water tower at top-left advertises the National Casket Company.

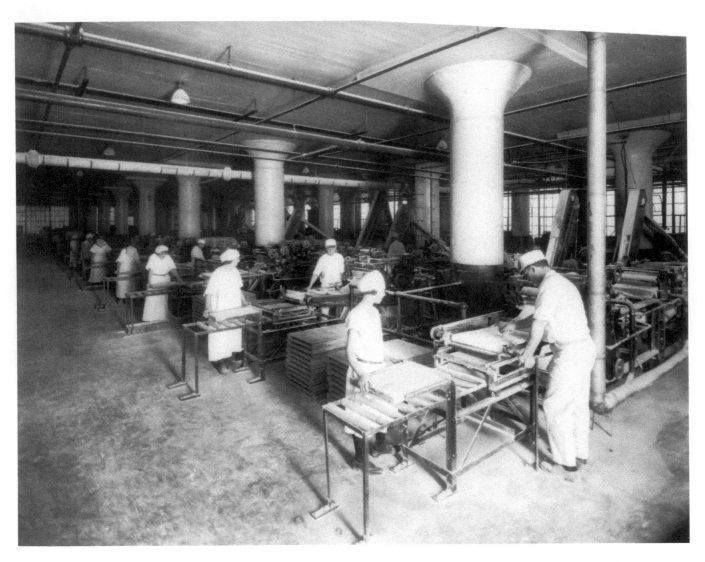

In 1899 William J. White and Dr. Edwin Beeman managed to get six other gum manufacturers to stick together to form the American Chicle Company. They had a plant in Manhattan but moved to Long Island City, where this photo was taken, in 1923. The firm imported gum from Central America to make such brands as Black Jack, Dentyne, and of course the familiar Chiclets. The Chicle Company was one of nearly 1,400 factories that solidified the area's economy.

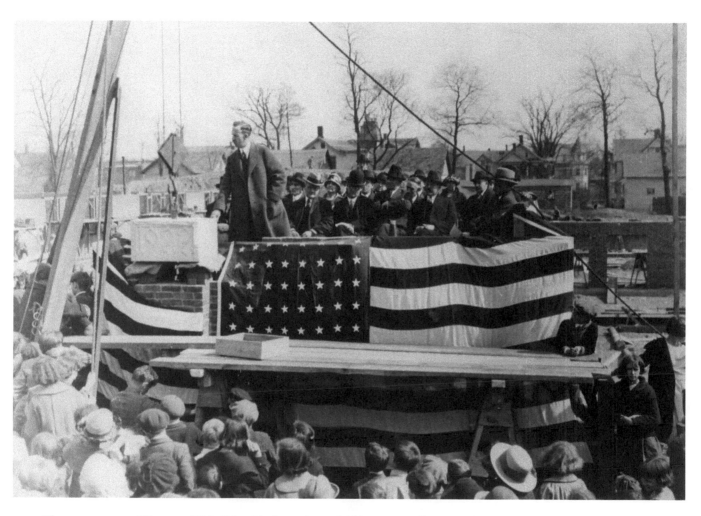

The cornerstone of Freeport High School is shown being laid in 1922. Village president Hilbert R. Johnson gave the keynote speech from the flag-draped dais as onlookers celebrated a symbol of community growth. Undoubtedly, many other politicians, educators, and town fathers spoke at the event.

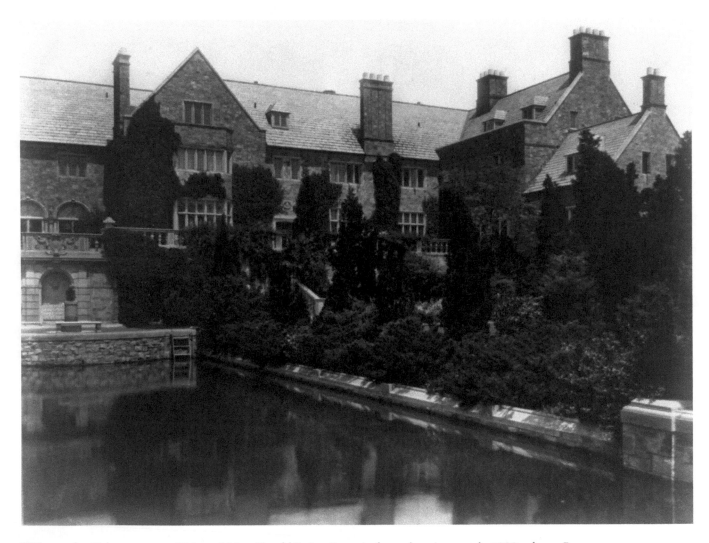

Welwyn, the 204-acre estate of Mr. and Mrs. Harold Irving Pratt, is shown here in an early 1920s photo. Pratt was a philanthropist and director of Standard Oil. His wife Harriet was appointed by Calvin Coolidge in 1925 to become the first presidential advisor on White House decor. Welwyn is now the home of the Holocaust Memorial and Educational Center of Nassau County.

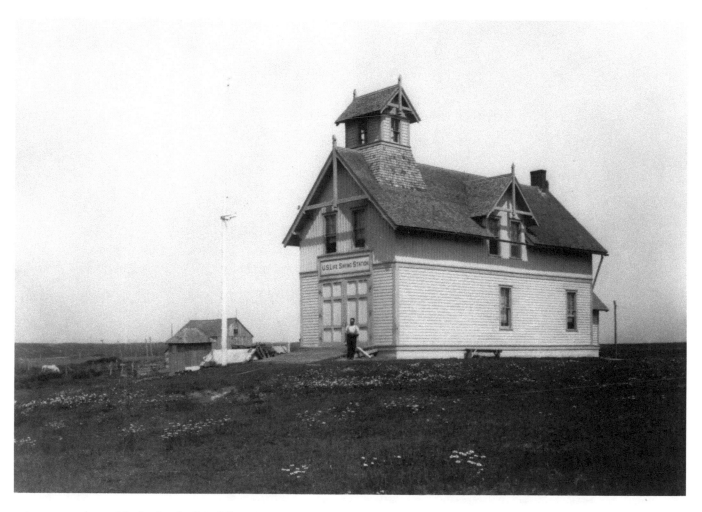

A man stands outside the Ditch Plain life-saving station at Montauk. Walter R. Jones, who owned a whaling fleet, established the Life Saving Benevolent Association of New York and constructed ten such stations, staffing them with volunteer crews to assist ships that foundered due to weather or accident. The stations were equipped with boats, wagons, rope, and an assortment of other life-saving gear.

This view shows the Glen Cove experimental sea farm, established in 1922 as a component of the Bayville Bridge hatchery. Oysters were cultivated at Glen Cove under controlled conditions. The fishing and shellfish industries contributed significantly to Long Island's economy.

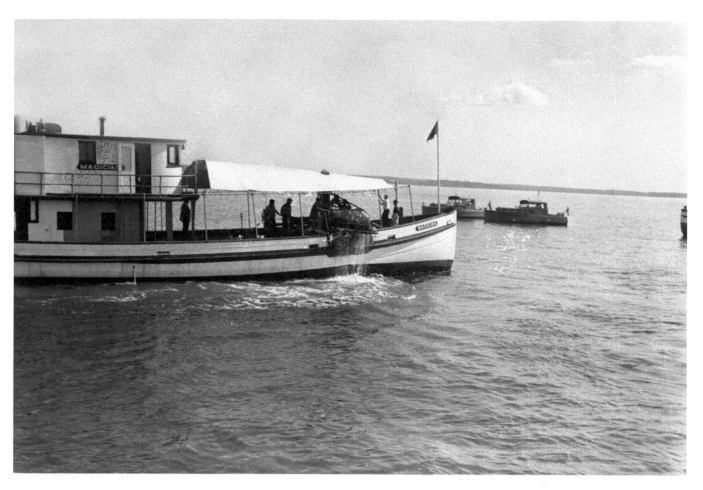

Sailors on the oyster dredger *Magician* haul aboard a day's catch around 1924. Such boats operated by dragging a dredge, a toothed bar with a bag attached, through an oyster bed. The near-pristine waters at the time gave up a bountiful catch on what was aptly named Oyster Bay.

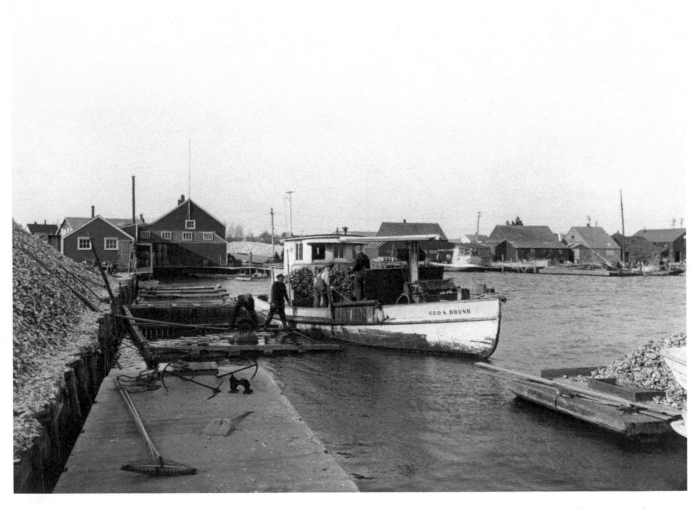

Crewmen unload a day's work from an oyster boat in Sayville. Floating docks were used to tie up the boats and transport the oysters to processing buildings. Oysters could be shipped whole to retail markets or processed. Shells would be ground and used for fertilizers; nothing was wasted.

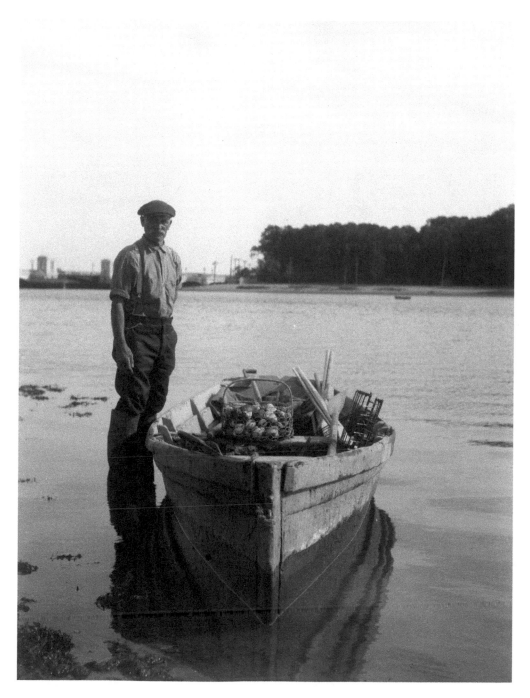

Individuals could also make a living in the Long Island shellfish industry, as is evidenced by this 1924 photo of William Stevens, who carries the proud title of "oysterman." He has his boat and his tongs and has arrived at the Bayville hatchery with the day's catch.

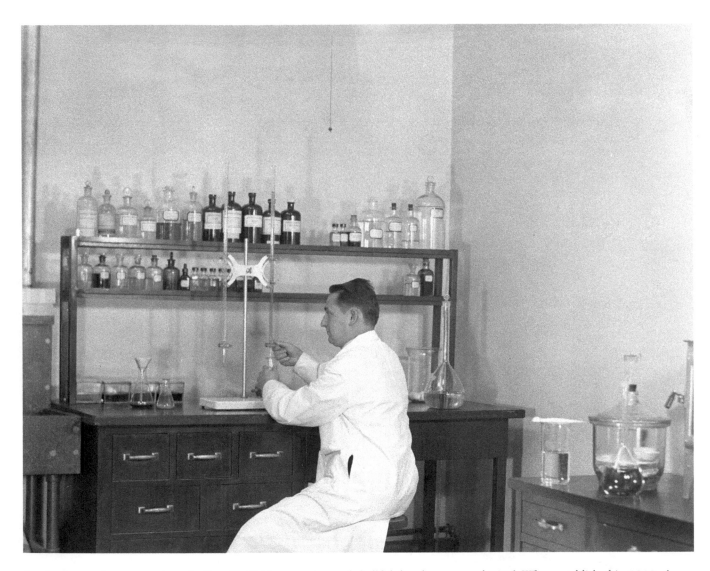

A scientist conducts research at the Bayville Bridge experimental shellfish hatchery around 1926. When established in 1922, the hatchery hoped to improve techniques for producing seed oysters on a large scale. The seed oysters would be planted in the beds to replace those harvested.

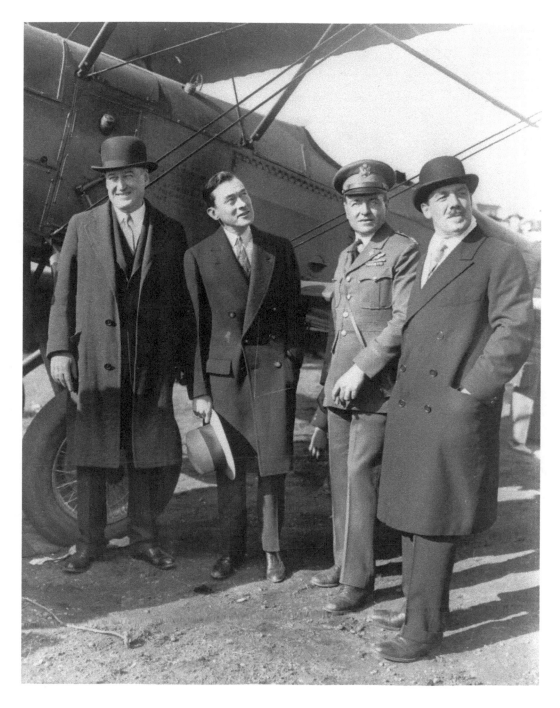

Jimmy Walker, mayor of New York City, was among the thousands waiting at Mitchel Field on Long Island for the arrival of the *Bremen* flyers who completed the first east-to-west crossing of the Atlantic in 1928. Herman Koehl, James Fitzmaurice, and Baron Ehrenfreid Guenther von Huenefeld were forced down on Greenly Island near Newfoundland. Their landing on a frozen pond caused damage to the plane, delaying their arrival on Long Island. Aviator Bernt Balchen led the rescue effort. From left to right are mayoral aide Charles Kerrigan, Mayor Walker, Captain Bender, and Grover Whelan.

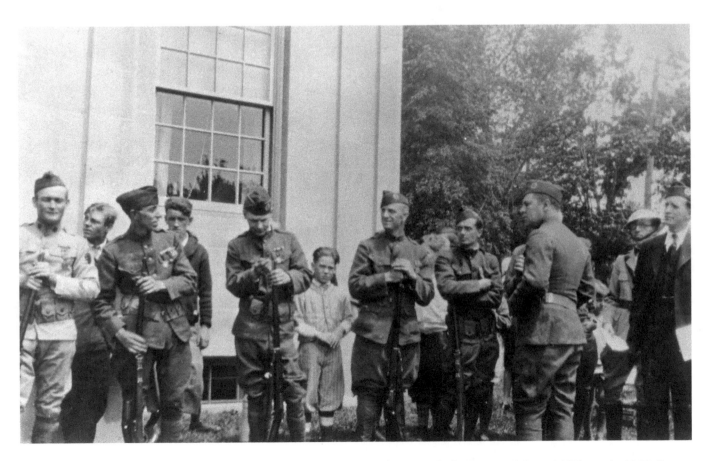

Veterans and soldiers from the American Legion Post 342, Freeport, gather outside the Freeport Memorial Library in 1928. Four years before, the library had been designated the first war memorial library in the state of New York. A plaque was later dedicated honoring those from Freeport who died in the Civil War, the Spanish-American War, and World War I. The places where the battles were fought were also inscribed.

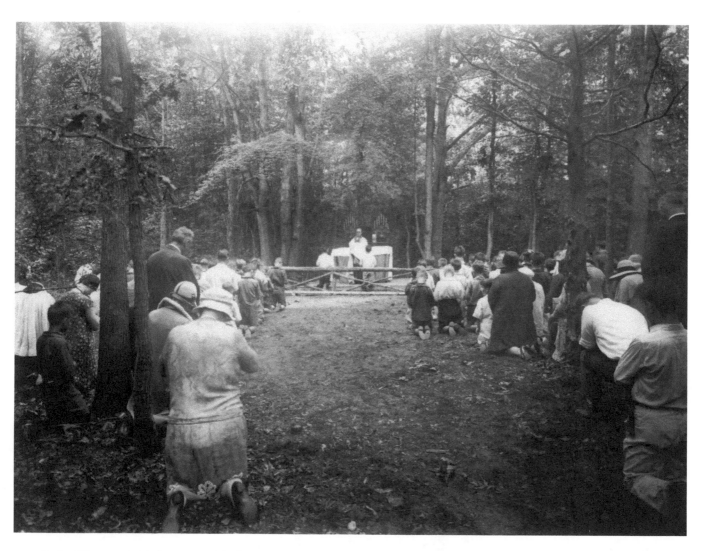

Father Thomas E. Molloy was archbishop of Brooklyn for 35 years. Among his many accomplishments was the founding of a Catholic-sponsored camp named after him and located in Mattituck. Catholic Youth Organizations, or CYOs, would attend Camp Molloy for summer fun. Spiritual needs were ministered to as well, as is shown here in this 1928 photo of a benediction.

This statue of Diana, Roman goddess of the hunt, stood on the Pratt estate grounds in Glen Cove. The prolific photographer Frances Benjamin Johnston captured this image and numerous others collected here.

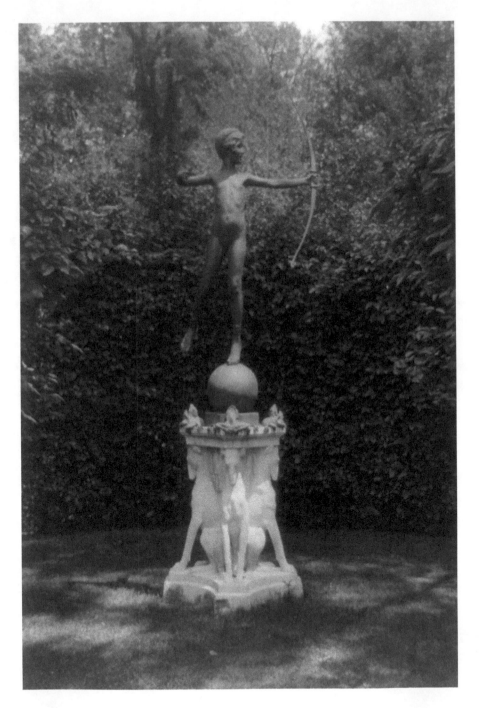

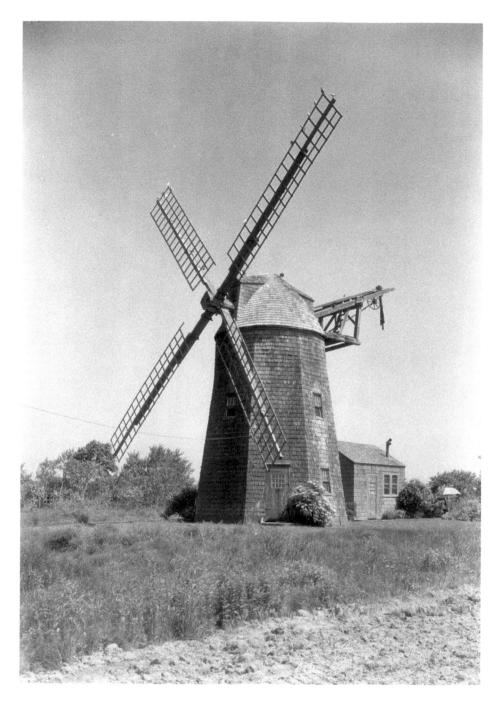

Long Island is relatively flat, and blowing winds could power windmills like this one at Hayground. Windmills served as gathering places for farmers while they had their grain ground. The fantail design dates this windmill to the early 1800s. Seen here in 1930, it had lately served as a tearoom and as an artist's studio. It was moved to East Hampton in 1950 and placed on the National Register of Historic Places in 1978. The south fork of Long Island has the greatest number of surviving windmills in America.

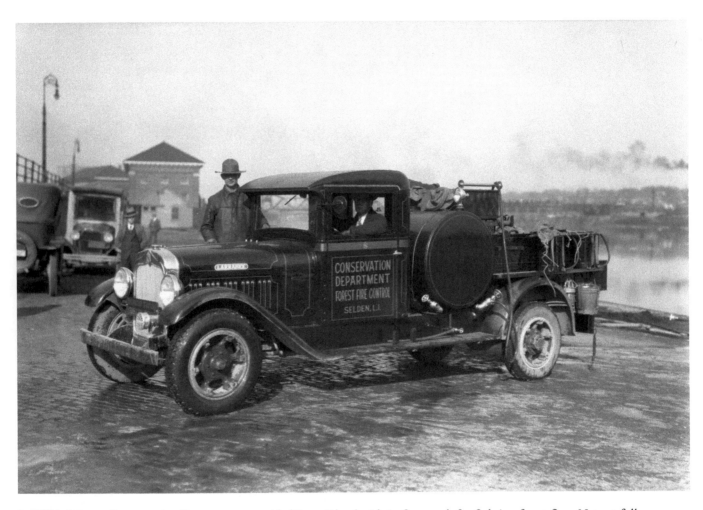

In 1924 the state Conservation Department provided Long Island with its first truck for fighting forest fires. Not yet fully developed, Long Island had large amounts of forest. Fire could be devastating because of winds coming off the ocean. Fire towers were also built to observe over large distances. These men were photographed with a Conservation Department forest fire truck in 1930.

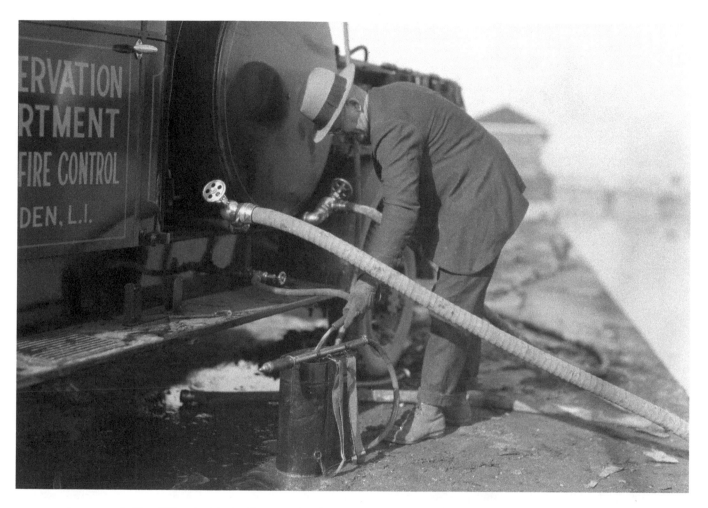

A man probably affiliated with the Conservation Department uses water from a department truck to fill the tank of a fire extinguisher to be worn on one's back. There were two primary fire seasons on the Island. The spring season was from March 1 to May 31. The summer season was from June 1 to September 15.

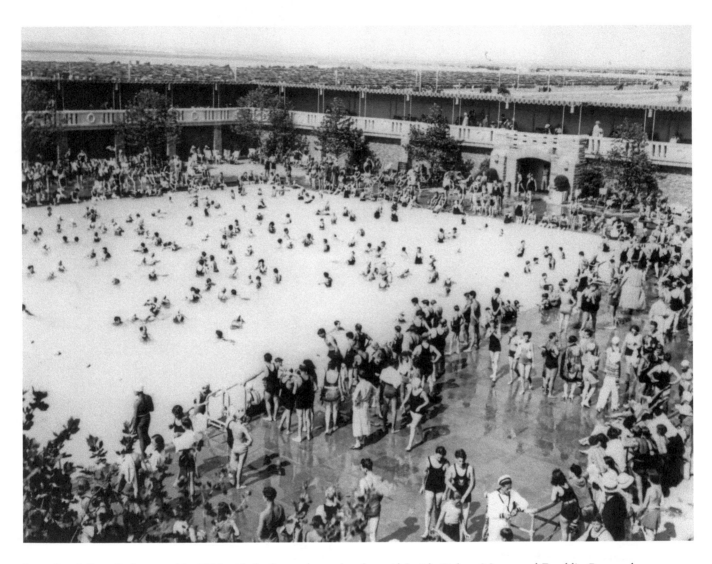

Jones Beach State Park opened in 1929 with fanfare and speeches from Al Smith, Robert Moses, and Franklin Roosevelt. A bathhouse with the pool seen here followed in July 1931, when this photo was taken. The state park was one means to protect the beautiful beaches of the Island, to keep them for the enjoyment of local residents as well as the thousands of visitors that still flock to the area year after year.

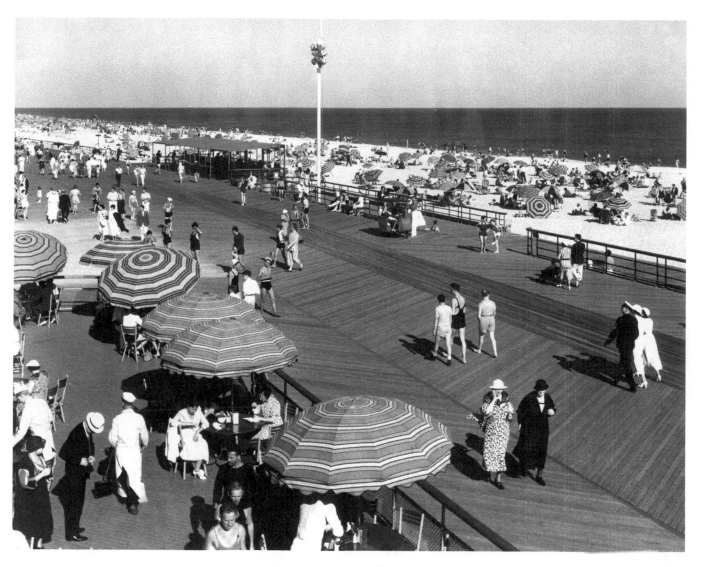

At Jones Beach in July 1934, people enjoy the beach, take a stroll on the boardwalk, or sit under umbrellas enjoying food and drink on what appears to be a glorious summer day.

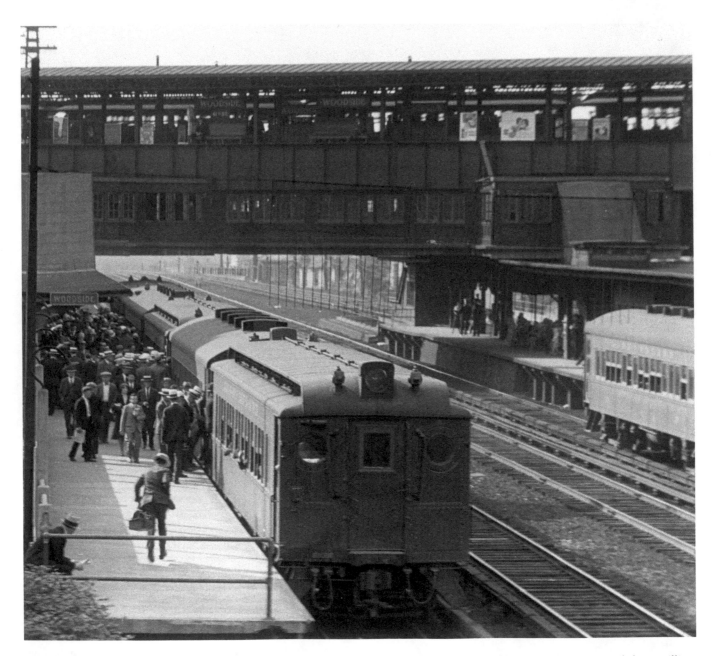

A crowd of commuters, nearly all men, board a train at Woodside in 1934. Most were probably among the estimated three million workers who made the daily journey to Manhattan that year.

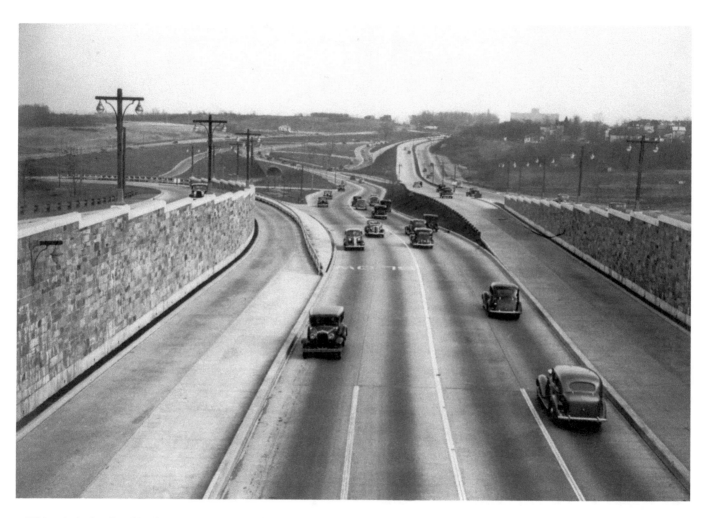

This relatively placid highway view in 1936 shows the junction of the Interborough Parkway, Grand Central Parkway Extension, and Grand Central Parkway. Confused? Try driving it today. The Interborough (now the Jackie Robinson Parkway) reaches from New York City into Nassau County. The Grand Central emerges from deeper in the city, allowing easier access to Island residents, and the extension was a widening and improving of existing roads.

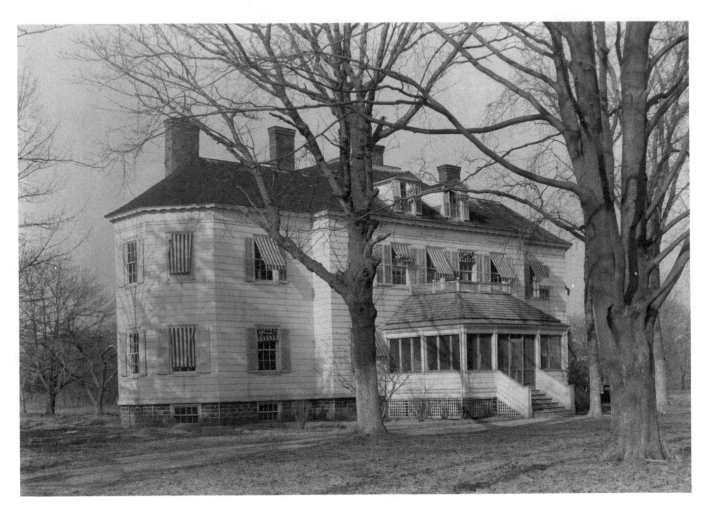

Thomas and Freelove Jones lived in Massapequa in the 1700s and became prosperous. Jones Beach takes their family name. In 1770 son David built a house at the head of Massa Creek that was the first "mansion" in the area. Originally called Tyron Hall, it later became known as Fort Neck House and is seen here in the early 1930s. Unfortunately, the house burned later that decade.

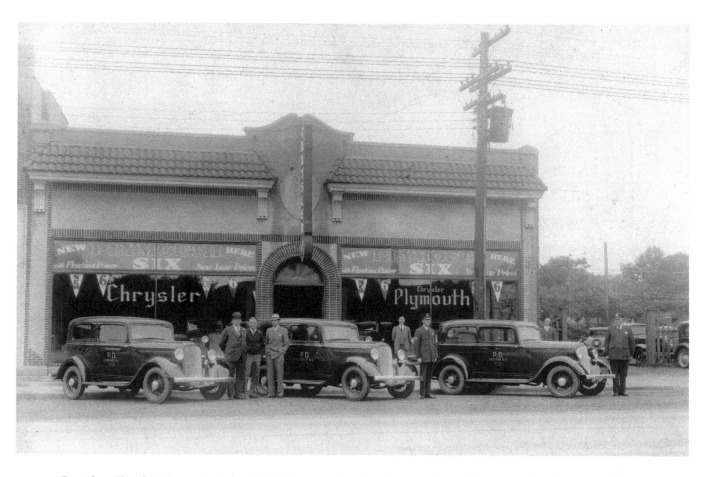

Outside a Chrysler-Plymouth dealership in Freeport, three brand-new police cruisers sit ready to be manned by uniformed personnel and detectives. The Freeport Police Department was established in 1893.

Wildwood State Park in Riverhead, Suffolk County, provided fun for the entire family in 1936 as it does now. The park begins on a high bluff overlooking Long Island Sound, and its 600 acres include campsites, beach access, and hiking and biking trails.

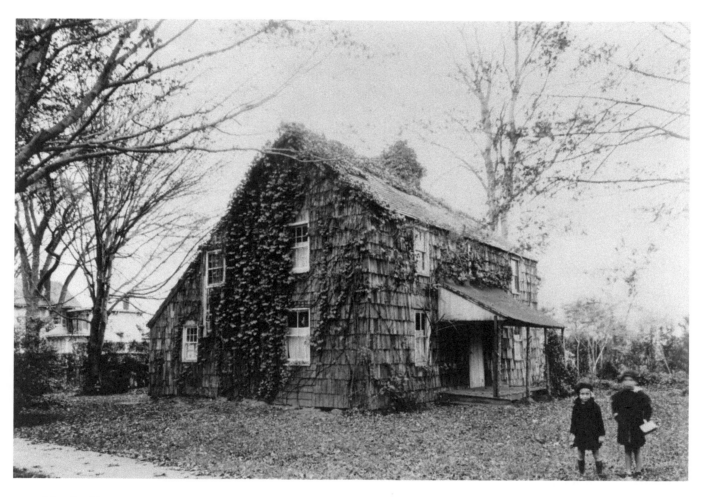

The Conklins were among the first English settlers to arrive in what became Amagansett in Suffolk County. This Main Street house, built around 1700, belonged to Ananias Conklin.

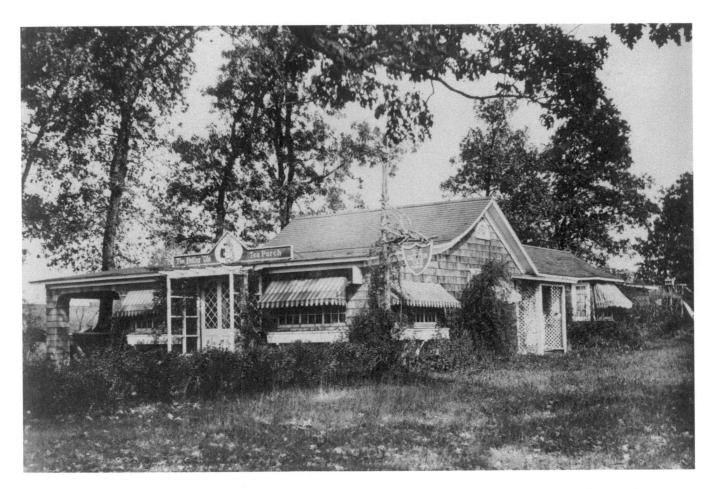

Located in the Town of Brookhaven, the Better 'Ole Tea Porch looked like it had perhaps seen better days by the time this photograph was taken.

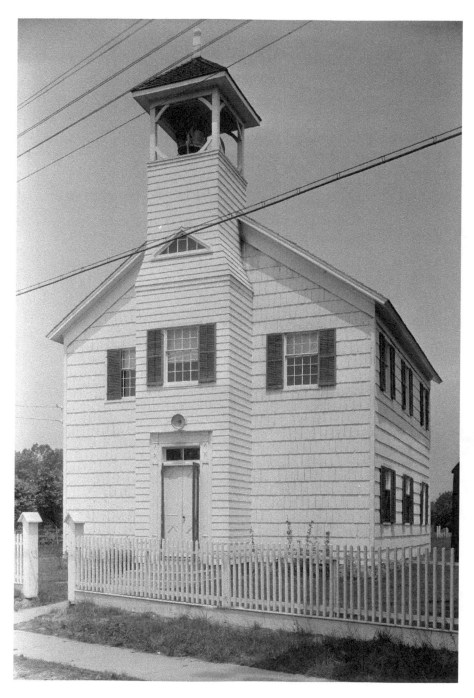

Dating to the early years of the nineteenth century, the First Congregational Church on Middle Country Road in what is now Lake Grove, near Centereach, was chosen to be the image to appear on the Lake Grove official seal.

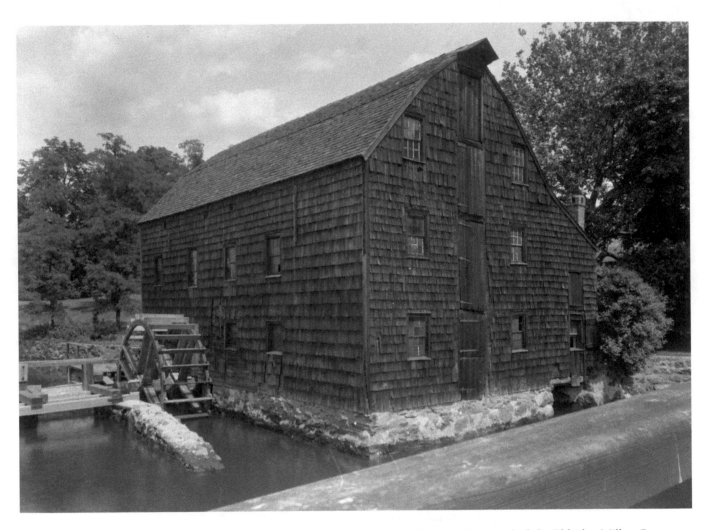

In June 1937, E. P. McFarland, working for the Historic American Buildings Survey, photographed the Eldridge Mill at Great Neck. A federal project inaugurated in 1933, the survey and its affiliated programs have documented more than 38,000 sites and structures.

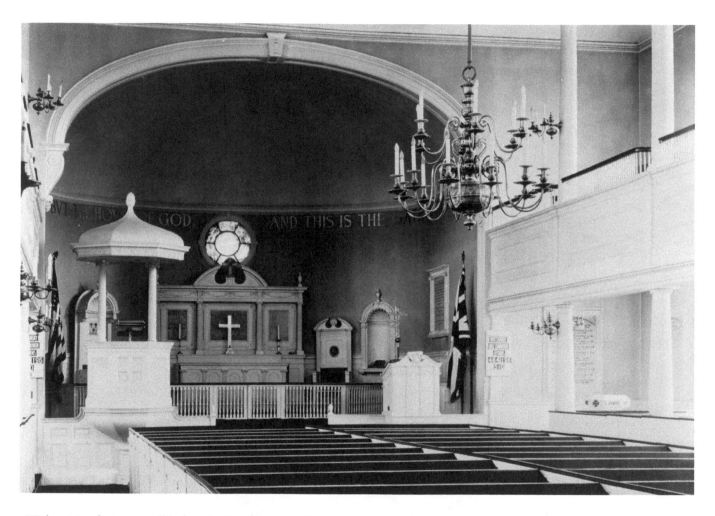

With origins dating to well before the Revolutionary War (and loyalist leanings during the war), St. George's Episcopal Church in Hempstead is among Long Island's oldest congregations. Located at 319 Front Street, the current church, seen here, was built in 1822 and is listed on the National Register of Historic Places.

The Pantigo Mill, built in 1804 on Mill Hill in East Hampton, was moved twice, the last time in 1917 to the house of Gustav Buek. The Buek residence had an earlier and better-known occupant in John Howard Payne, composer of the song "Home Sweet Home," for which the house has since been named. It was converted to a museum in 1928.

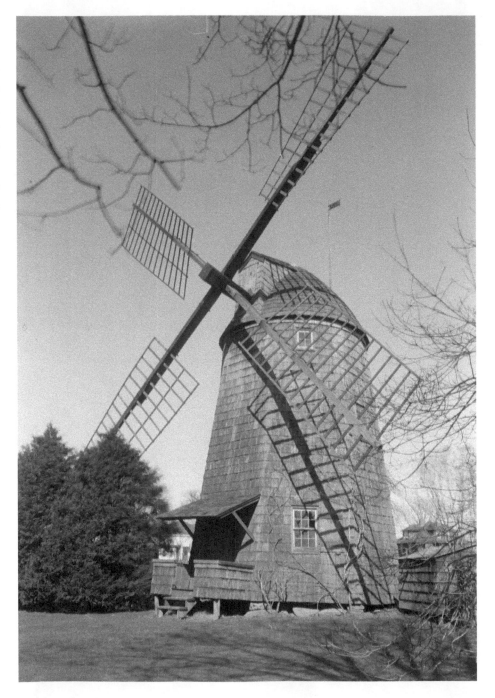

World War II and Postwar Prosperity

(1940–1960s)

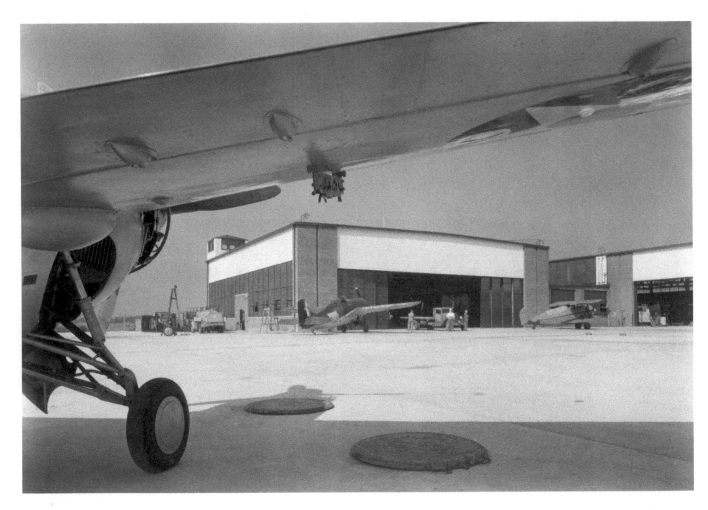

Grumman Aeronautical Engineering Company was a major airplane manufacturer founded in Baldwin in 1930 but located in Bethpage by the time of this 1940 photo. In its early years the firm built and tested commercial aircraft, but with the threat of war mounting, it shifted focus to the military. At center, near the hangar, can be seen one of its most famous aircraft, the F4F Wildcat fighter. Grumman, which later became Northrop Grumman, maintained a presence in Bethpage for many years after the war.

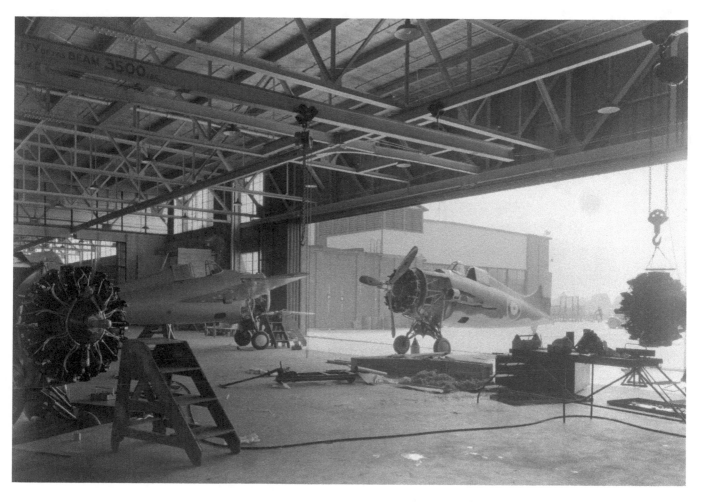

An interior shot of a Grumman hangar shows airplanes in various stages of assembly. At right a motor is mounted on a fuselage and is waiting for wings, at center a fighter is nearly completed, and at left a motor is resting on a hoist. In 1944 Grumman brought out the F6F Hellcat, one of the most highly effective of the World War II fighters.

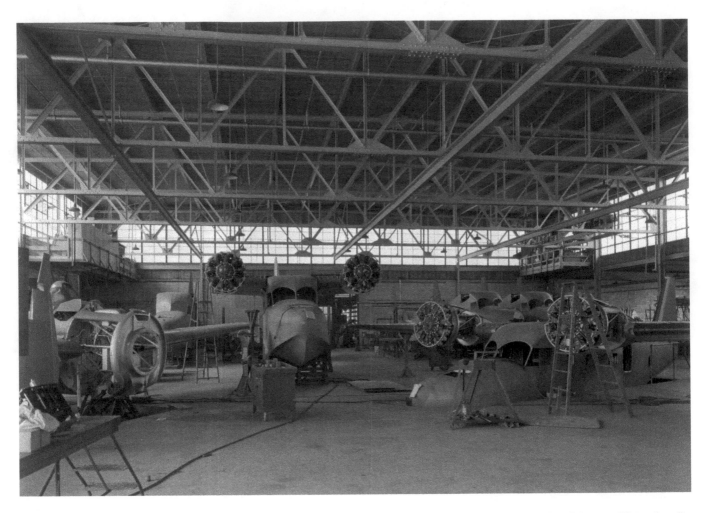

This interior shot of a Grumman hangar shows the full assembly operation. These aircraft are most likely of the JRF "flying boat" model used for coastal defense and submarine patrol. The photo was taken in October 1940, more than a year before U.S. entry into World War II, and some of the aircraft were undoubtedly built to be sold. But even at this early date, war preparation was under way.

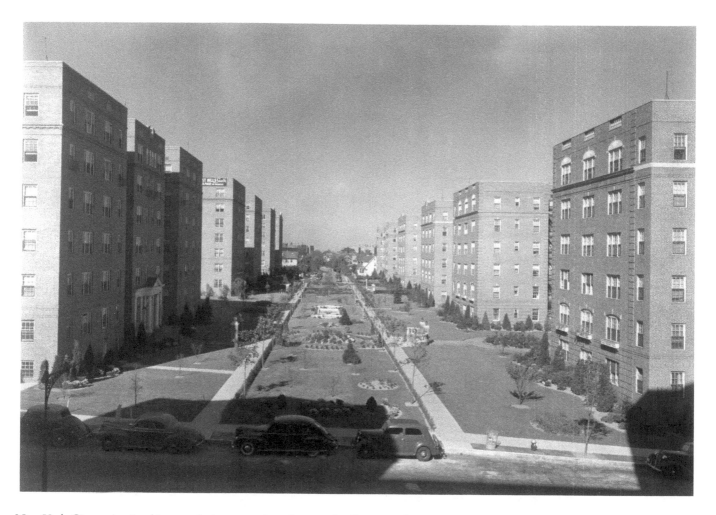

New York City maintained its population even though many families moved to Long Island. Because of the abundant land available on the Island, various industries expanded there and workers and their families followed. To keep up with the demand for living space, apartment complexes like this one photographed in Forest Hills in 1941 began sprouting in many towns.

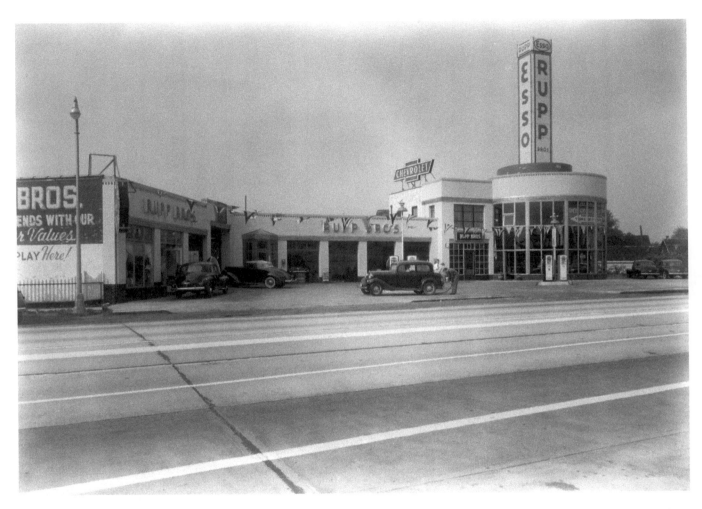

Motoring around the Island was essential, whether for work or play. Though rail travel was well established, America's love of the automobile was growing as the Depression eased and more people could afford one. Rupp Brothers service center in Lynbrook, sporting the Esso brand, has plenty of bays to cater to the public in June 1941—whether to fill her up, rotate the tires, or change the oil.

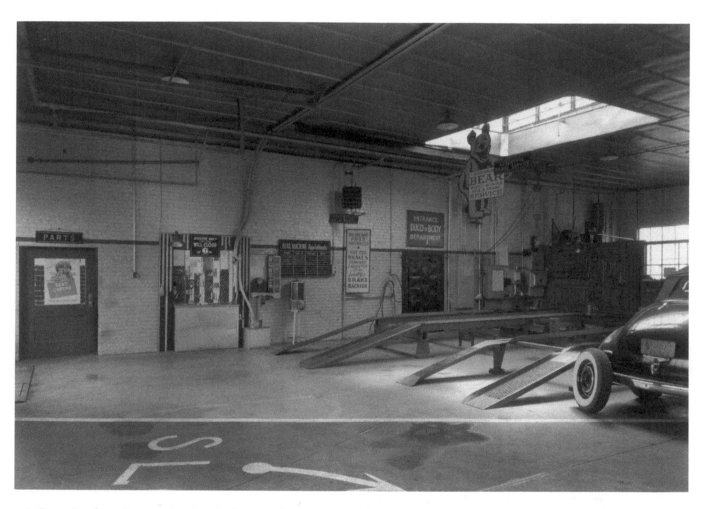

At Rupp Brothers Garage in Lynbrook, the parts department is at the rear, and two racks sit empty, waiting for a jalopy to roll in The bear sign found in countless garages across America hangs near the skylight.

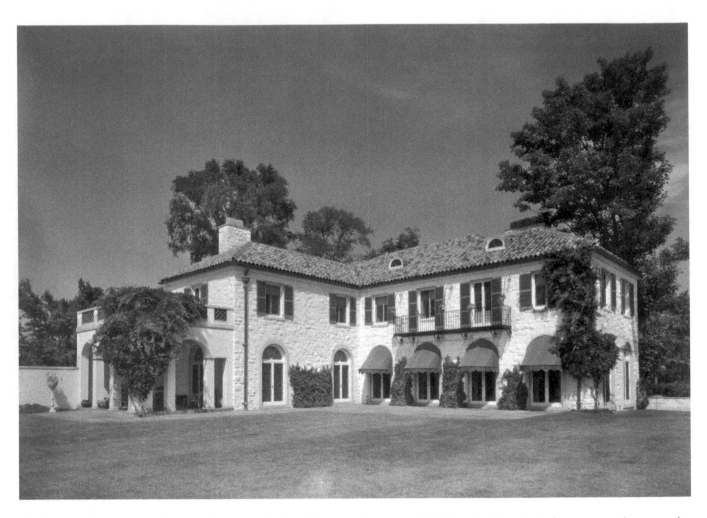

The home of Sarah D. Gardiner on Main Street in East Hampton is seen in 1942. The Gardiner family has roots on the east end of Long Island dating back to 1639 when Lion Gardiner purchased a 3,300-acre island in what would become Gardiner's Bay. The island has remained in family hands into the twenty-first century. It is legend that pirate William Kidd left some booty buried beneath its shores.

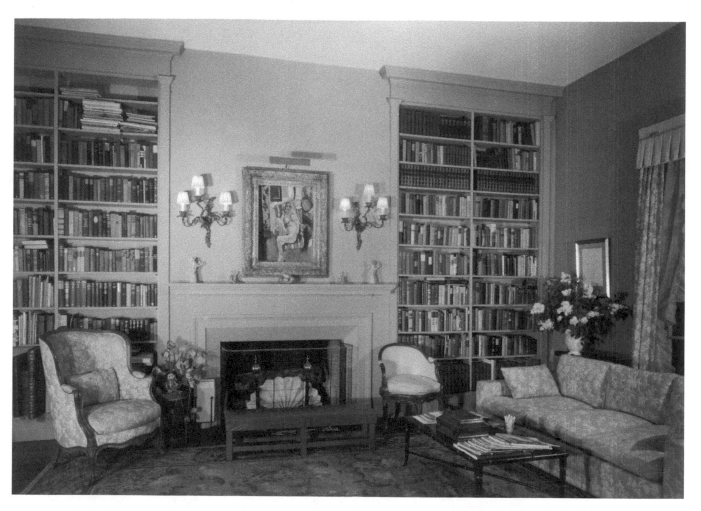

If walls could talk—this is broadcast pioneer William S. Paley's library at his house in Manhasset in 1942. Paley built the CBS radio and television empire, including the network news division he developed with correspondent Edward R. Murrow, whom he met in London during World War II. Paley had the genius to combine news broadcasting and advertising. Perhaps some of his planning took place here.

Mitchel Field received its name in 1918 to honor a former mayor of New York City, John Mitchel, who died while training for aerial combat in World War I. The field made significant contributions to aviation in the period 1918–1941. World War II made it more important. Here, troops are "dry firing" Thompson machine guns before advancing to the next stage of training, firing them on a range with live ammunition.

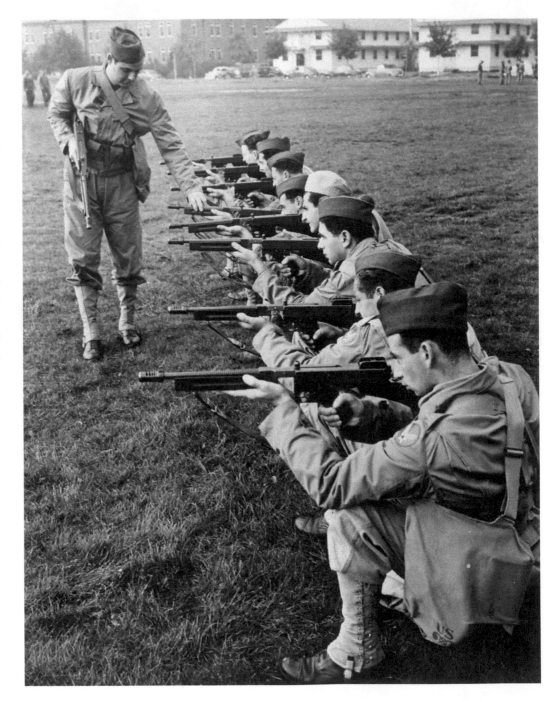

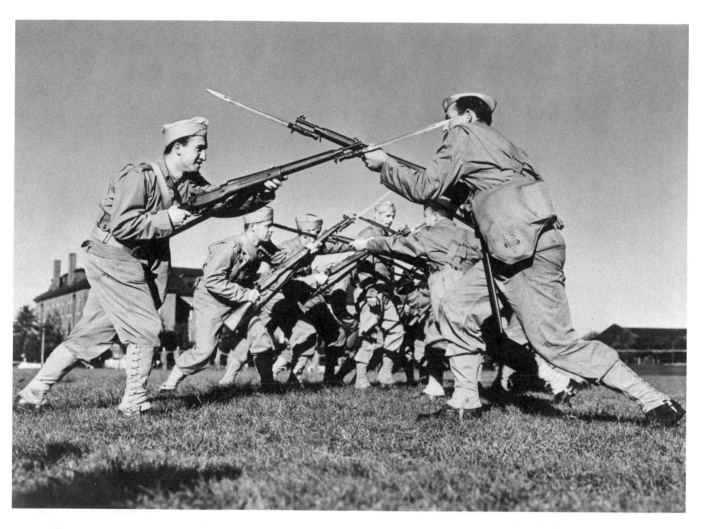

The troops at Mitchel Field were not ground infantry, but technicians for the air squadrons. However, this didn't mean they weren't combat ready. Here men sharpen their bayonet skills under the eyes of Captain Clifford W. Vedder (center).

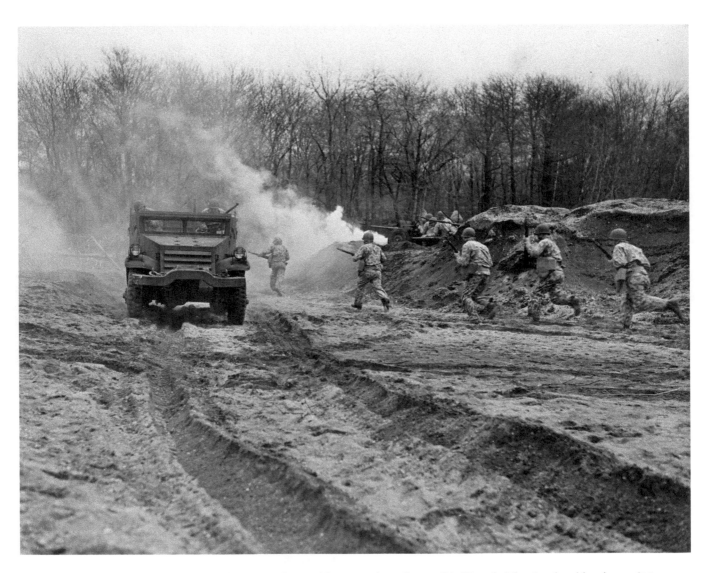

More training at Mitchel Field is shown here in 1943 as soldiers assault an "enemy" half-track. The simulated battle conditions are real enough to the men, as a smoke grenade covers one position while a squad bravely attacks the armored vehicle.

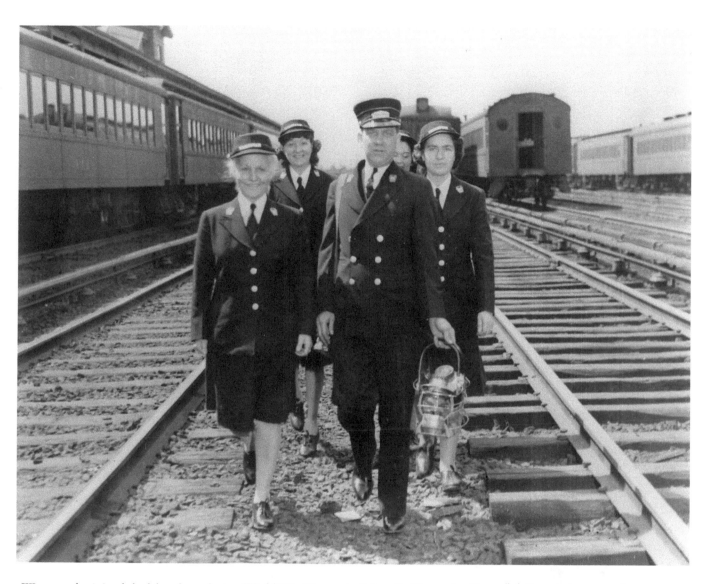

Women who joined the labor force during World War II weren't all literally "Rosie the Riveter" defense industry workers. Women entered many essential fields that had been the traditional domain of men. Here women trainmen, as they were called, return from their first run on the LIRR in 1943. An instructor brakeman, carrying the signature tools of his trade, flag case and lantern, accompanies them.

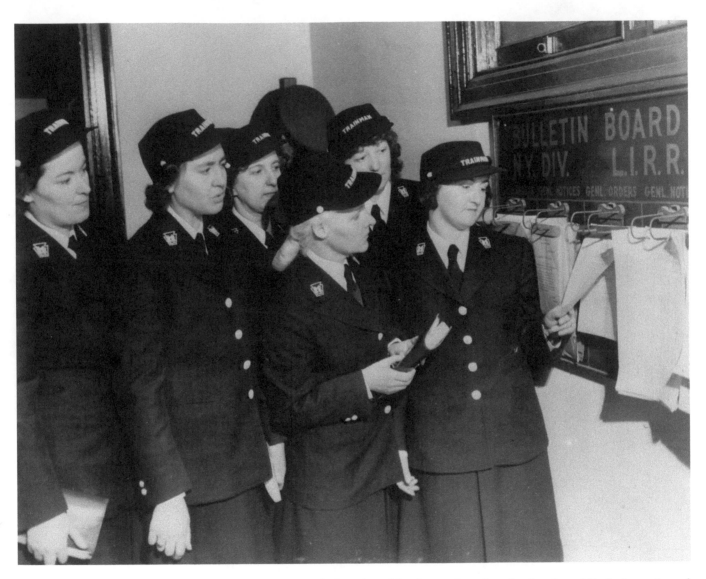

Women working for the LIRR check the crew dispatcher's bulletin board for their train orders. Serving the public during a time of crisis, filling an important job in a different kind of uniform, the lives of the women had changed forever.

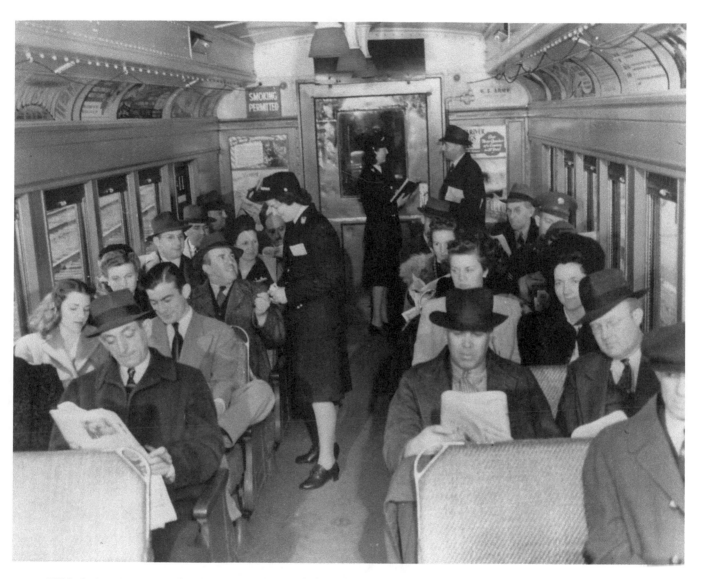

With their training completed, two women take their posts in the passenger coach. Florence L. Lawyer collects tickets while Marcella Craft gives timetable information to a passenger at the rear. The commuters are absorbed in their newspapers, and the coach, although a little ornate, seems similar to what we ride today.

One would hardly know from this photo of the Stony Brook business district in June 1943 that there was a war on, were it not for the absence of men on the street. At the start of the decade the village had been given an architectural makeover by philanthropist Ward Melville of the Thom McAn shoe empire, with the town's columned post office as focal point.

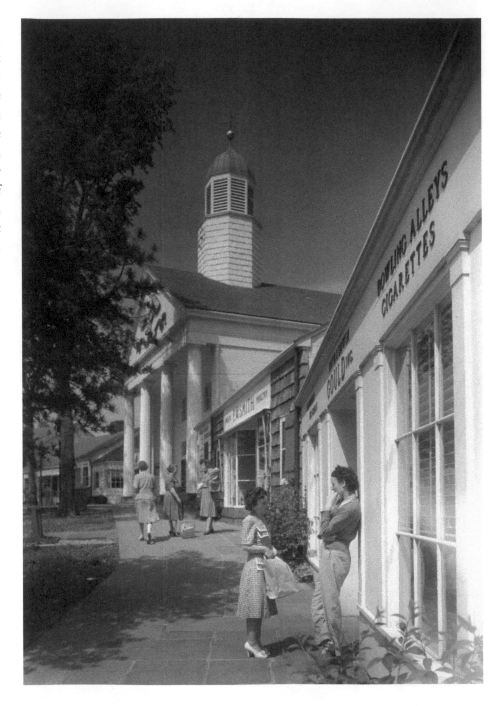

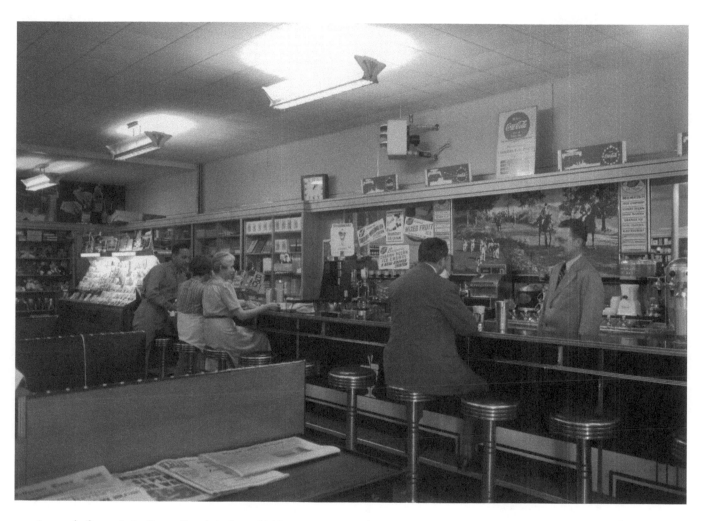

At a soda fountain in Stony Brook in June 1943, customers are chatting and possibly ordering a "two cents plain." Newspapers with war news line the table in the foreground, but the patrons seem to just want to take a break and relax on an early summer afternoon. State-of-the-art lighting, heating apparatus (on the wall), and cash register accent the decor.

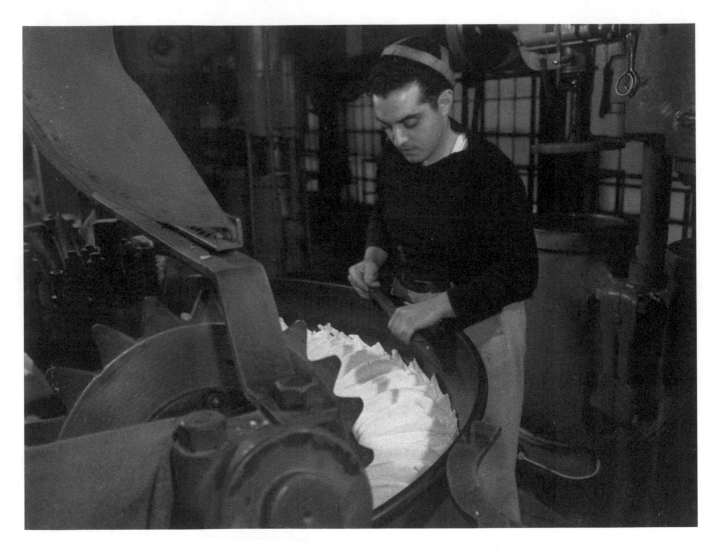

A worker at the Atlantic Macaroni Company in Long Island City puts pasta on a drying rack in 1943. Four partners were responsible for the start of the company in 1892. One decided to venture out on his own; in 1915 Emanuele Ronzoni started his now famous namesake company. The New York metropolitan area was the second-largest pasta market in the world, so there was room for competition.

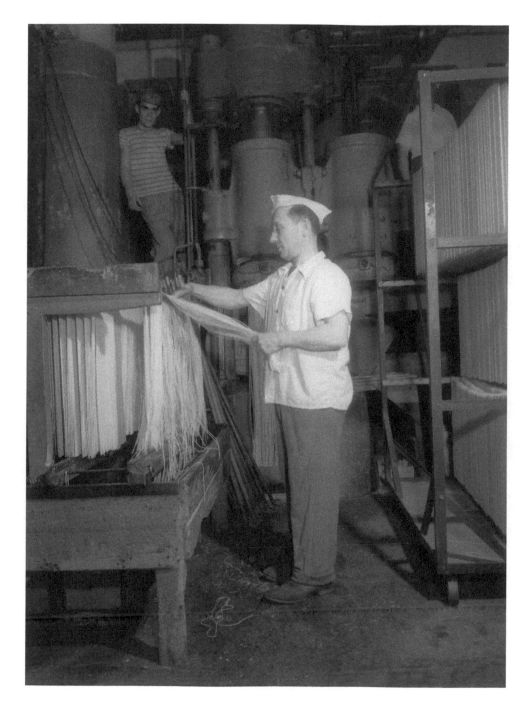

Another step in the process of drying pasta—in this case, spaghetti—is demonstrated at the Atlantic Macaroni Company. Food rationing was a necessity during World War II, and pasta was a staple food at a time when stretching meals was a patriotic duty.

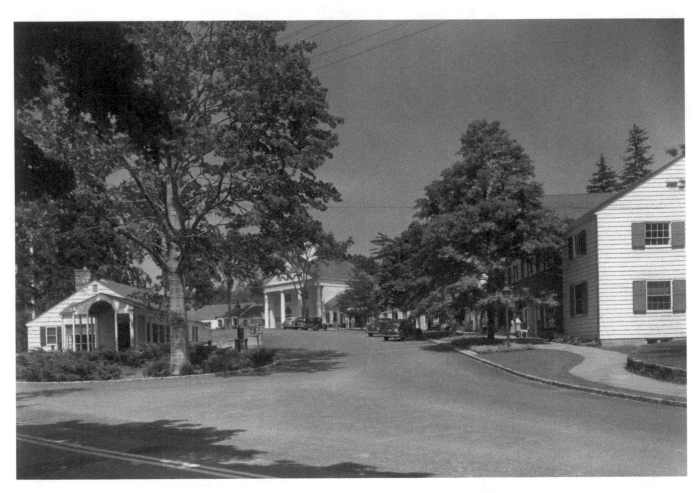

This street view shows a quiet, pastoral Stony Brook in 1943. Modest housing and spacious streets are characteristic of a number of suburban towns that dot Long Island.

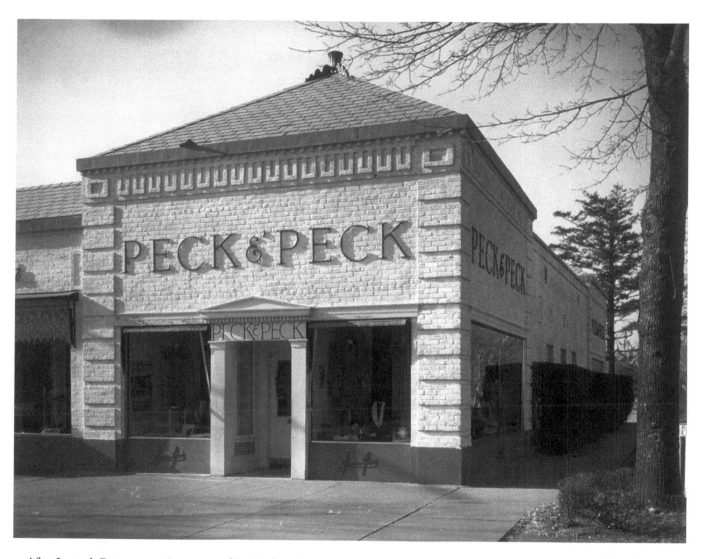

After Loeser's Department Store opened in Garden City during the 1930s, high end shops from New York City followed. While Loeser's supplied wares for less affluent Long Islanders, specialty shops like Peck & Peck, a women's clothing retailer, offered more upscale brands. The store was located on Franklin Avenue, which became known as the "5th Avenue of Long Island" as trendy shops began to appear.

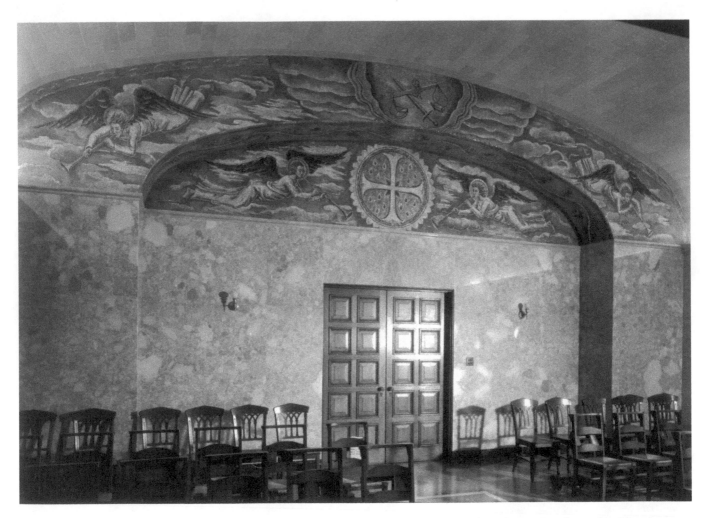

Angels trumpet above the archway and auditorium doors of the Seminary of the Immaculate Conception, located in Huntington. The Roman Catholic seminary was established in 1930 to prepare men for the priesthood. It continues its work today, offering master's degrees in theology and doctoral degrees in ministry.

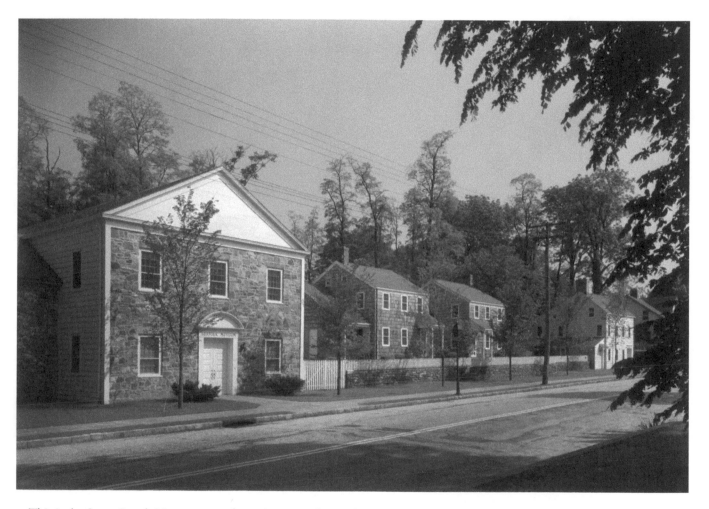

This is the Stony Brook Museum complex as it appeared in 1943. It is now called the Long Island Museum and has been greatly expanded to include the Margaret Melville Blackwell History Museum, the Smith Carriage Shed, and an excellent art museum. It is now affiliated with the Smithsonian Institution.

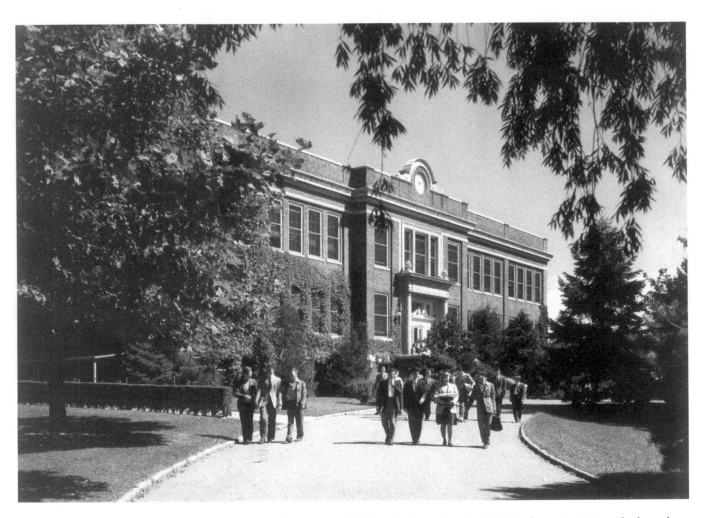

Students leave the main building of Woodmere Academy in 1943. The school was founded in Woodmere in 1912 and adopted the motto *Disce Sirvere,* or "Learn to Serve." In 1990 it merged with Lawrence Country Day School to form the present Lawrence Woodmere Academy.

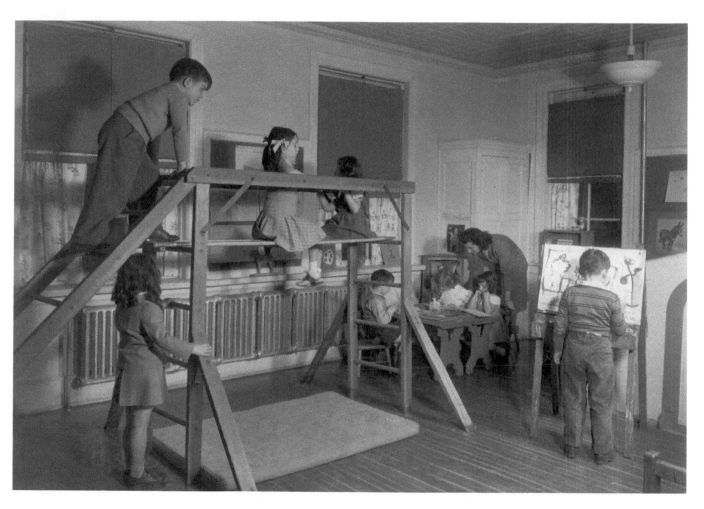

A teacher attends to her students in a kindergarten classroom at Woodmere Academy. The scene shows quite a mix of physical, scholastic, and artistic activity and resources.

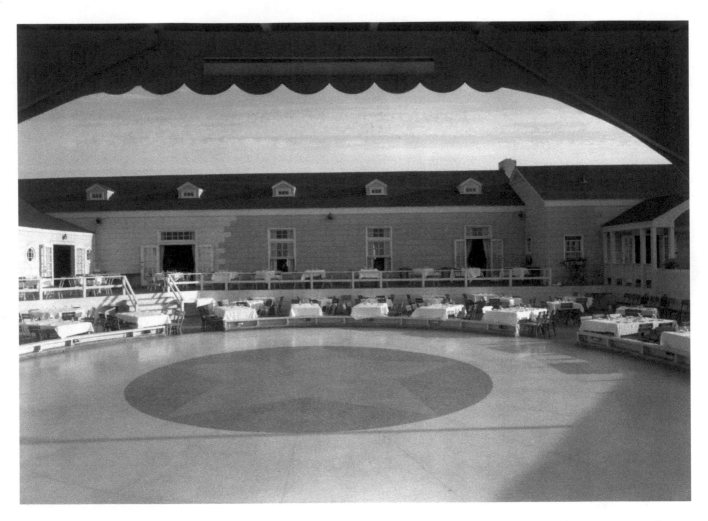

In 1946, when folks still "touch danced," the Surf Club at Atlantic Beach provided an outdoor venue. With men returning from Europe or the Pacific, dancing under the stars on a romantic evening was the continuation of the American dream. Couples got back to the routine of life, and started the baby boom.

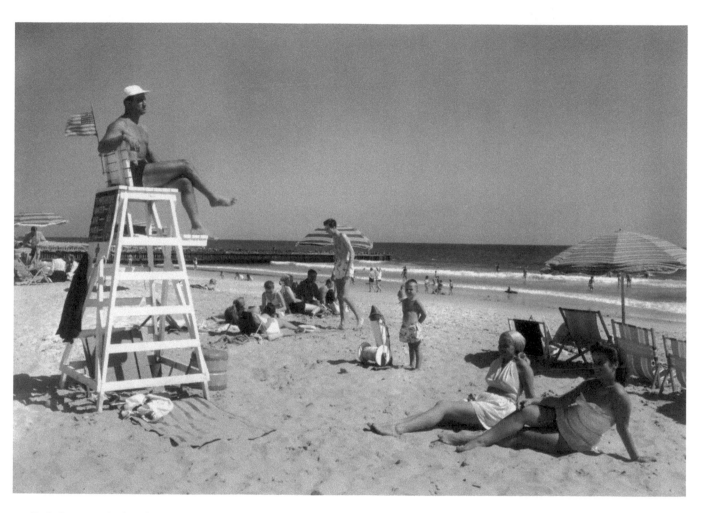

Frolicking on the beach is part of the culture of Long Island, as seen here at the Surf Club on Atlantic Beach in August 1947. A relatively young community at the time, Atlantic Beach was developed by Stephen Pettit of Freeport in the 1920s.

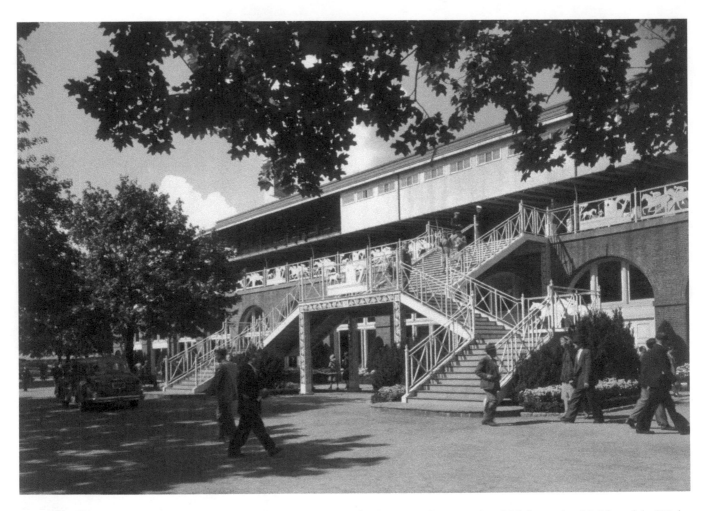

A summertime passion for many on Long Island is horse racing. The famous Belmont Park, which hosts the third leg of the Triple Crown of thoroughbred racing, is located in Queens. It opened in May of 1905 and is named for August Belmont II. Virtually every champion racehorse of note has run on this one-and-one-half-mile track, including Secretariat, who set the Belmont Stakes record of two minutes, twenty-four seconds in 1973.

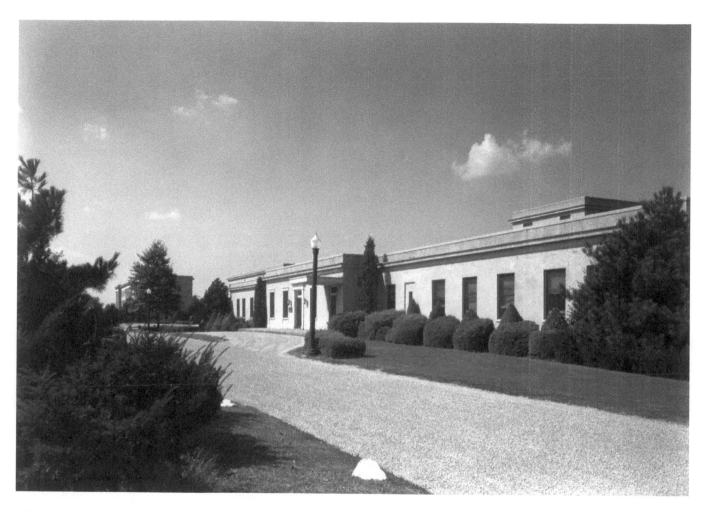

Shown here in 1946 is the Meadowbrook Hospital on Hempstead Turnpike in East Meadow. Built in 1935, it became the Nassau County Medical Center in 1974, and the Nassau University Medical Center in 2001. The name changes illustrate the growing population of Long Island and the commitment to providing its residents with quality medical care.

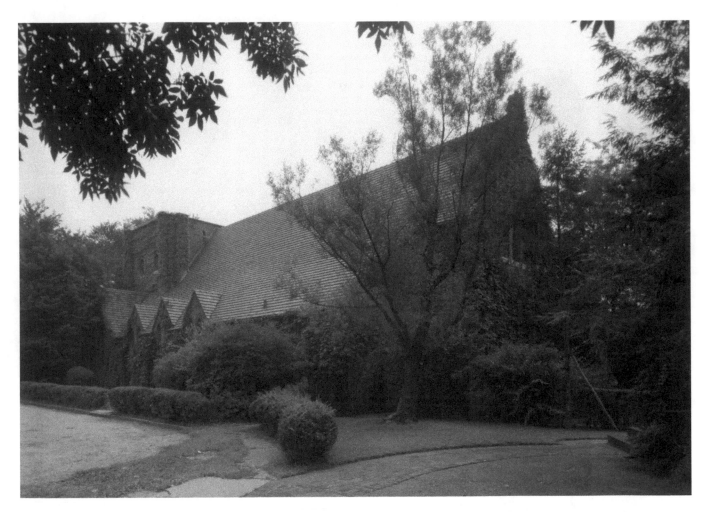

This 1947 exterior view shows St. Luke's Episcopal Church in Forest Hills. The congregation was formed in 1913 and worshiped in a wooden chapel until the present stone structure was erected. The design is English Gothic, and the first rector was William Lander.

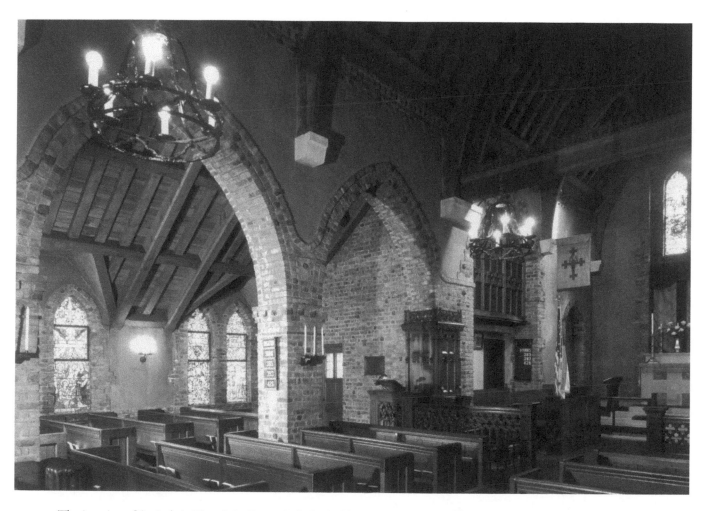

The interior of St. Luke's Church in Forest Hills looks like a medieval castle. Completed in 1924, the church was designed by Robert Tappan, a member of the congregation simultaneously involved with construction of the Cathedral of St John the Divine in Manhattan. By 1949, when this photo was taken, there had been a mass movement to the suburbs from the city, and people wanted to celebrate their faith. Many varied denominations had found homes on Long Island since colonial times.

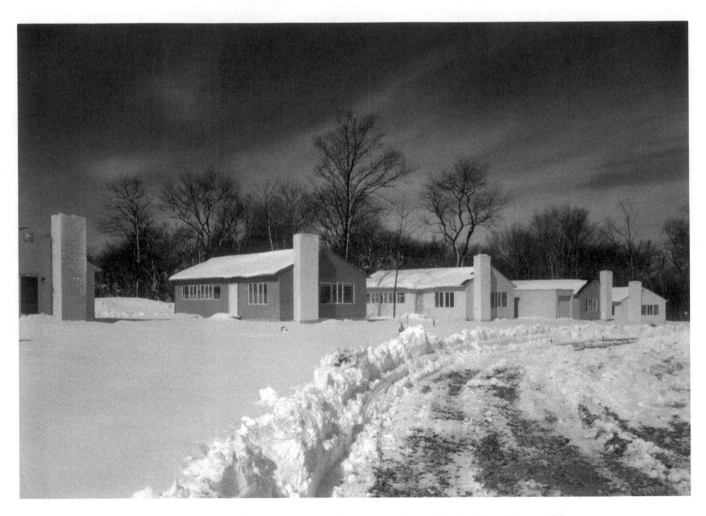

Syosset Gardens was typical of the housing developments springing up on Long Island. A "cookie cutter" house meant a new start in a grand place. Families now wanted fresh air and backyards for children to play in, rather than crowded city streets. The Island had the space and the affordability. By 1949 memories of bad times were fading, and all were eager for prosperity.

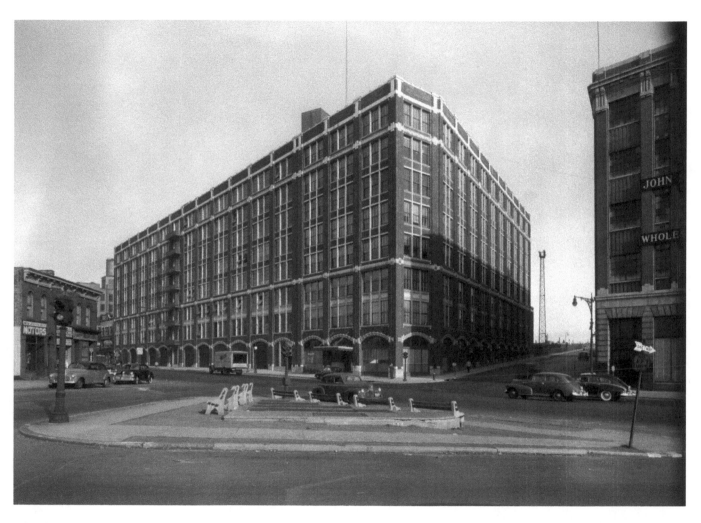

The pharmaceutical firm E. R. Squibb & Son took up an entire city block with this facility on Northern Boulevard in Long Island City. By 1948, when this photo was taken, returning soldiers were eager for work and new careers.

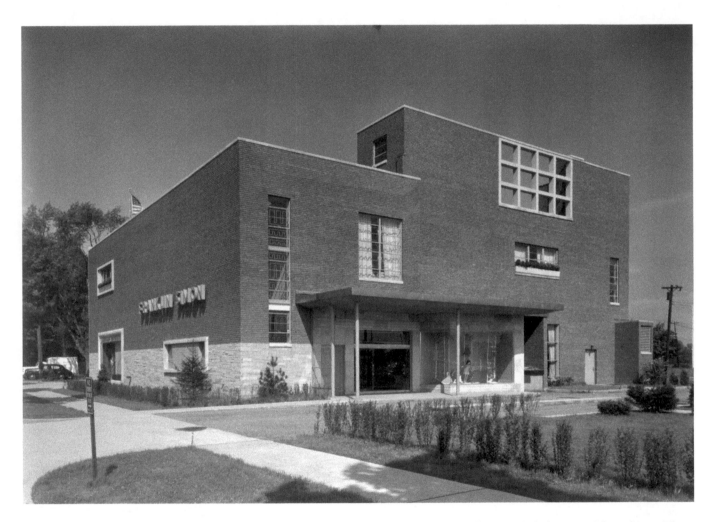

In 1902 Franklin Simon and Herman Flurscheim opened a store in New York City to sell women's fashions and furnishings. The Franklin Simon store proved successful, and in 1932 a branch store opened in Greenwich, Connecticut, signaling a move into the suburbs. The Franklin Simon shop in Garden City is seen here in 1947. By the time the chain closed in 1979, there were 42 stores.

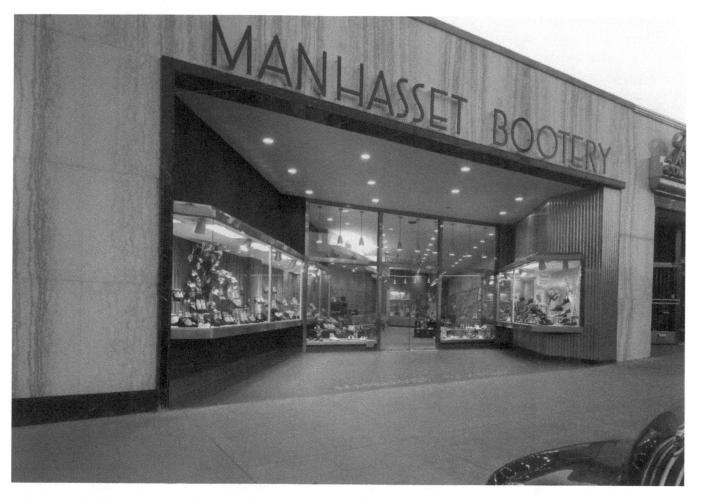

The Manhasset Bootery was located at 505 Plandome Road in Manhasset. Plandome Road was a main artery running parallel to Manhasset Bay, and dozens of specialty shops were located along it. The bootery appears to have a substantial selection of shoes for the entire family.

Located at 66 Colonial Drive in East Patchogue, the radio station WALK broadcast at 1370-AM and served Long Island and the New York metropolitan area. It was a 500-watt station whose motto was "the greatest music ever made," and whose pioneer disc jockeys were Ed Wood, Jr., and Jack Ellsworth. Like most stations in the pre-format era, WALK varied its programming from music to news to local events. The station is seen here in 1952.

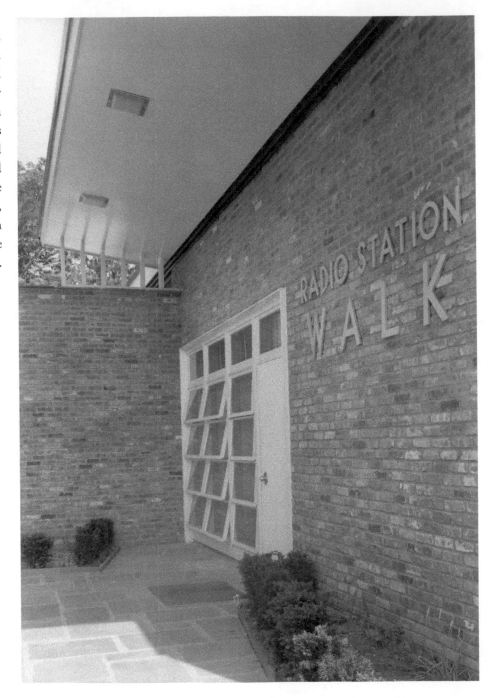

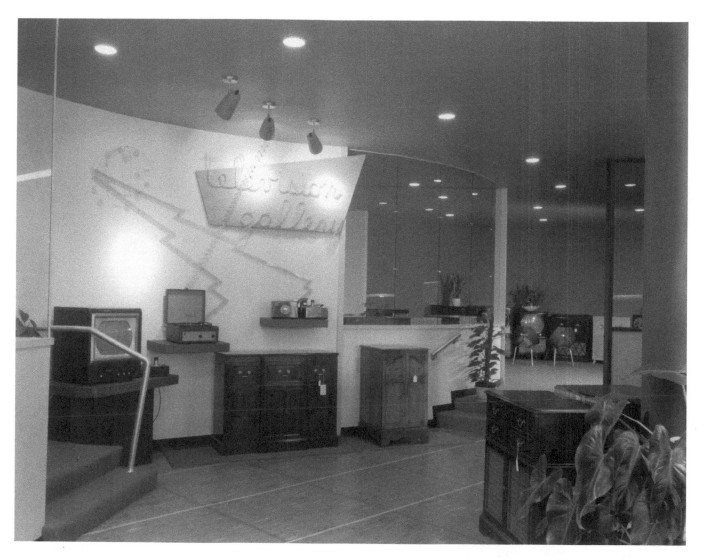

Stevens Radio on Steinway Avenue in Astoria has all the modern conveyances of home entertainment in 1950—large console radios, small table radios, a 78-rpm record player, and the infant product, a television set. In addition to WALK, Long Island radio stations such as WBIC, WLIE, WGSM, and WHLI were the places on the dial for news, sports, and music fare.

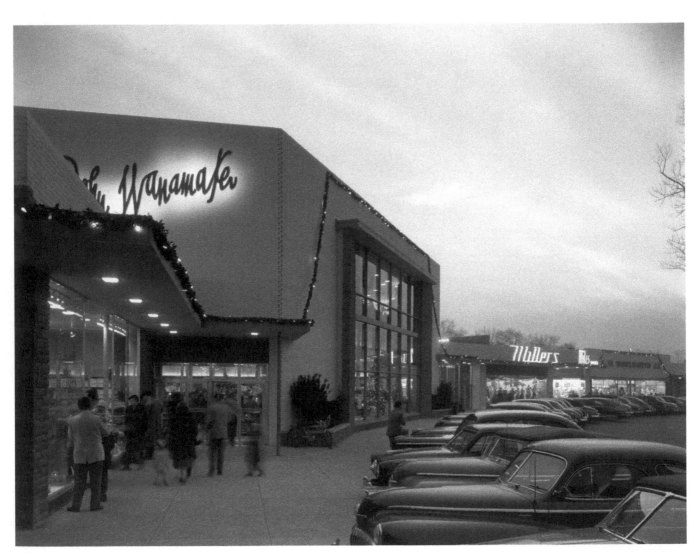

The Wanamaker department store at a shopping center in Great Neck is decorated for the holidays in this December 1951 photo. The store bore the name of the family who pioneered the department store in the United States. With Long Island continuing to grow, the chain knew it could prosper.

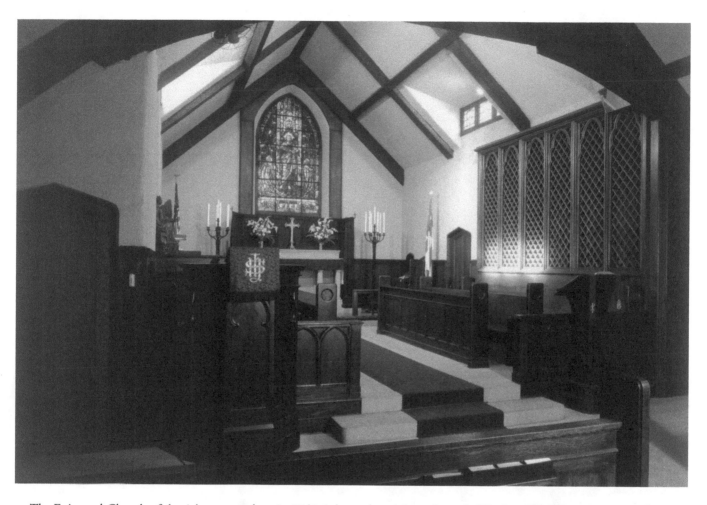

The Episcopal Church of the Advent, seen here in 1948, is located on Advent Street in Westbury. Built in 1910, it was designed by famed architect John Russell Pope, who also designed the Jefferson Memorial and National Archives Building in Washington. Its brush with fame occurred in 1914 when June bride Martha Bacon married financier George Whitney. Society pages were abuzz with news of a guest list that included such names as Morgan, Roosevelt, Vanderbilt, and Belmont.

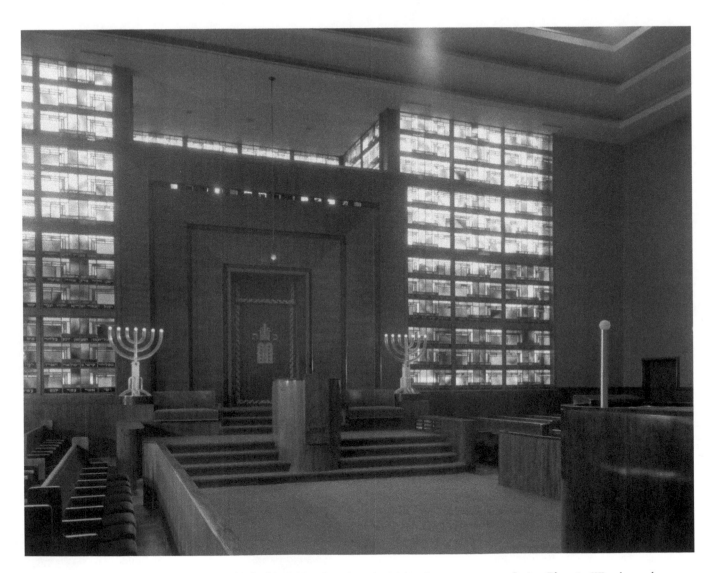

The Congregation Sons of Israel was established in 1927. Seen here in 1951, the synagogue on Irving Place in Woodmere has tripartite seating, meaning men on one side, women on the other, and a mixed seating area in the middle, so that all may worship together at traditional Jewish services.

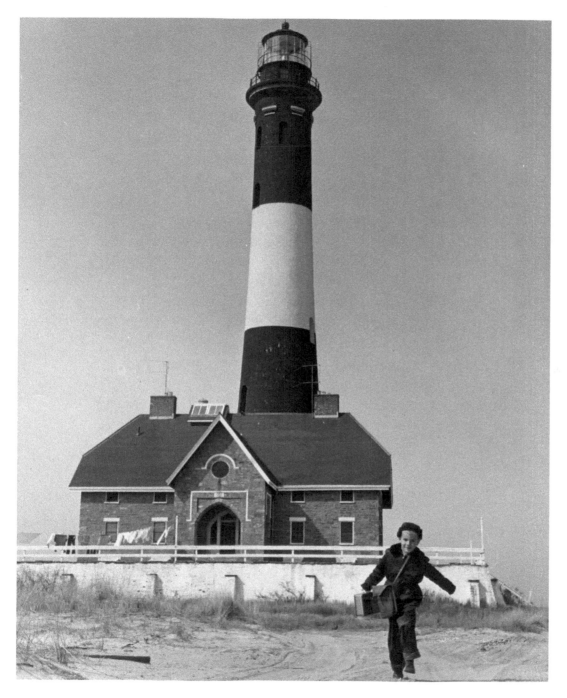

This 1952 photo shows young Richard Mahler running to catch his ride to Fire Island School. His father is the lighthouse keeper at the Fire Island Light House in Suffolk County. If Richard had to do show-and-tell in class, all he probably had to do was say, "Look out the window."

In 1952, when a new theater was completed at Jones Beach, Broadway impresario Mike Todd mounted the first extravaganza performed there, a production of the operetta *A Night in Venice*. Todd is shown here with the theater behind him.

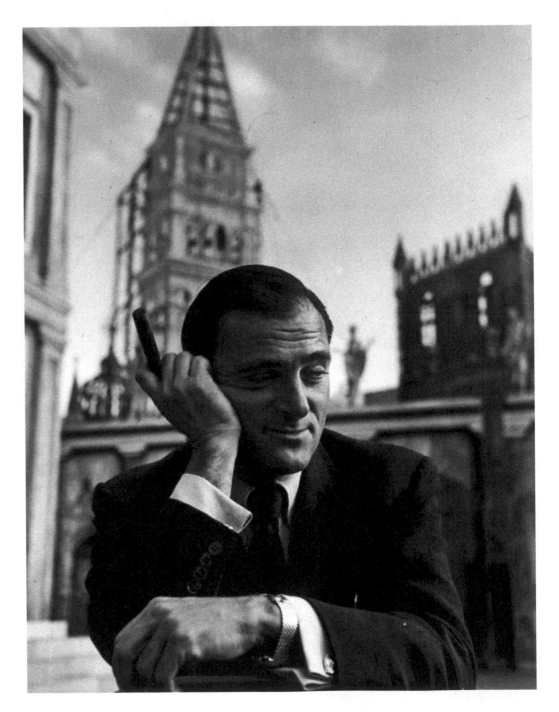

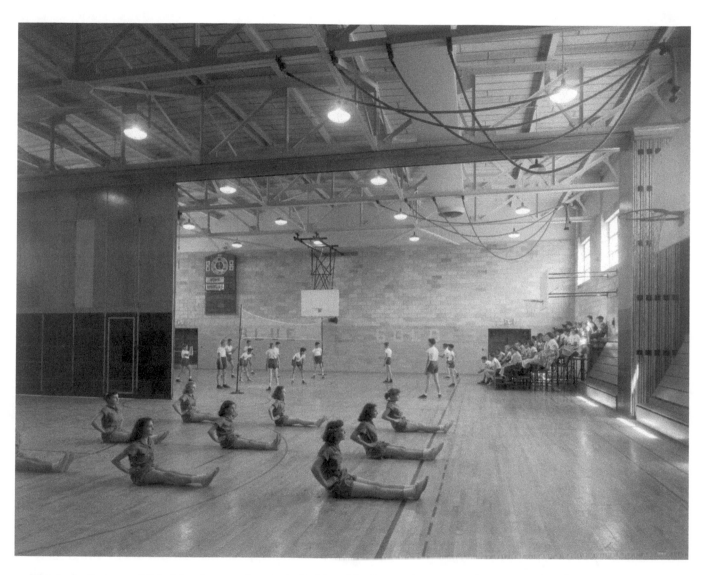

This is the Bethpage High School gymnasium in 1952. The girls, doing calisthenics, take their physical education separate from the boys, who are playing volleyball in front of a group of spectators.

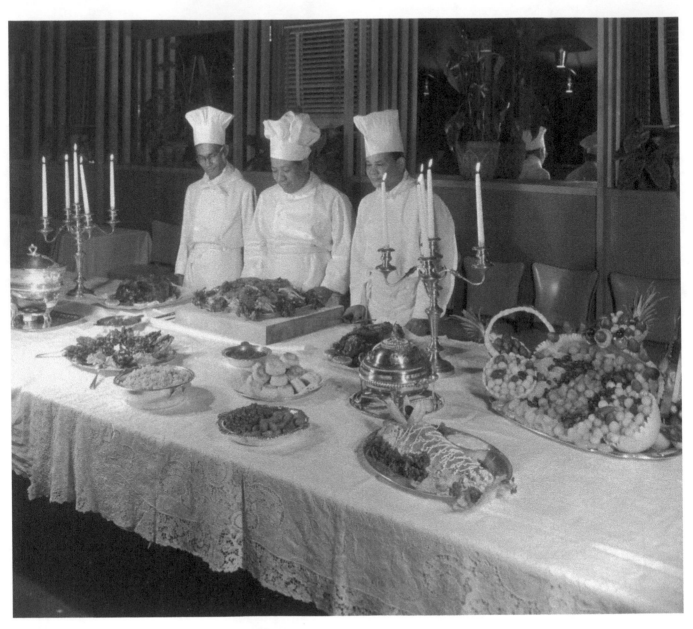

Here is one of the lavish banquet tables at Patricia Murphy's, a restaurant in Manhasset. The staff stands ready to carve the meat, ladle the gravy, and serve the side dishes. The photo was taken in June 1952, so this could be a banquet setting for a wedding.

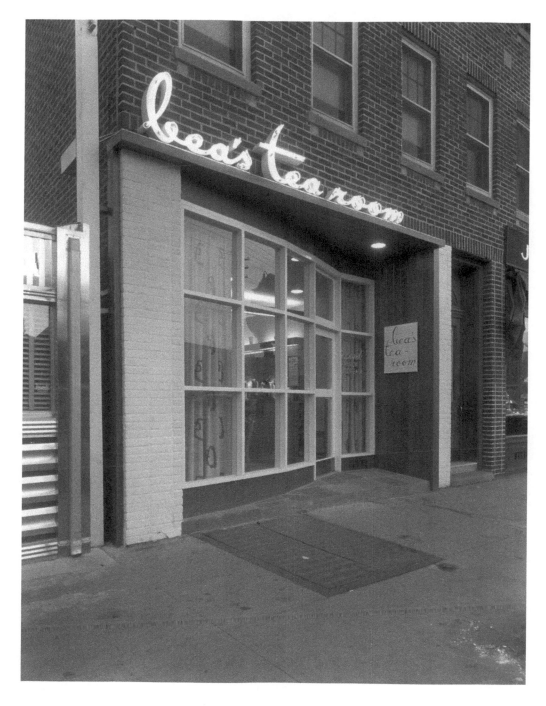

Seen here in 1952, Bea's Tea Room was located in Cedarhurst. It was a local business where people could stop, relax, take tea, and see what the rest of the day would bring. It brought a unique flavor to the neighborhood.

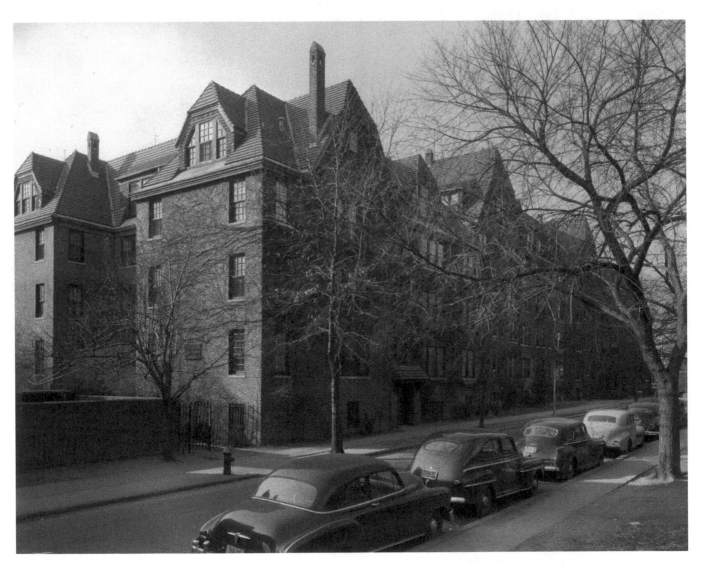

Seen here in 1952, the Tennis Apartments were located on Dartmouth Street in Forest Hills, longtime home of the U.S. Open tennis tournament. Forest Hills was an early twentieth century planned community where one could walk to the clay-court West Side Tennis Club and perhaps encounter Margaret Olivia Slocum Sage, or Frederick Law Olmsted, Jr., two of the planners involved in creating Forest Hills. Most of the complexes were eventually demolished for more upscale development.

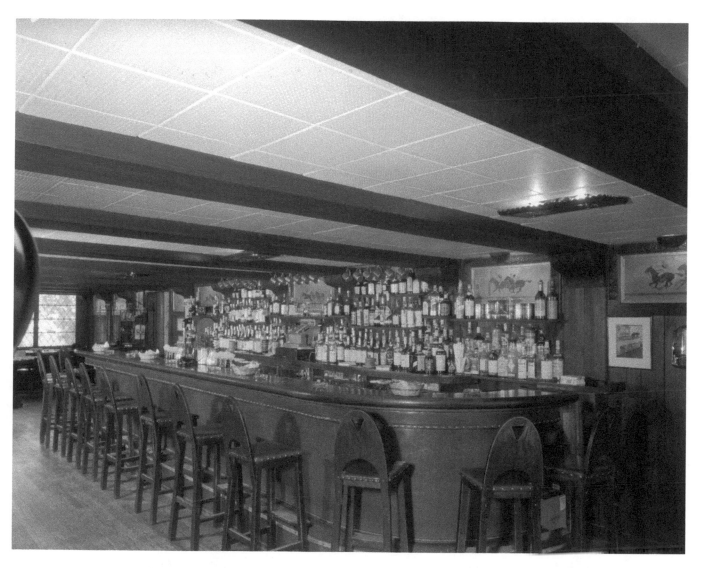

This is the well-stocked bar at the Blue Spruce Inn in Roslyn in 1953. It was a noted place for food and drink but didn't always have a quiet atmosphere. Some live jazz recordings were made there in 1965 by a quartet led by trumpeter Henry "Red" Allen.

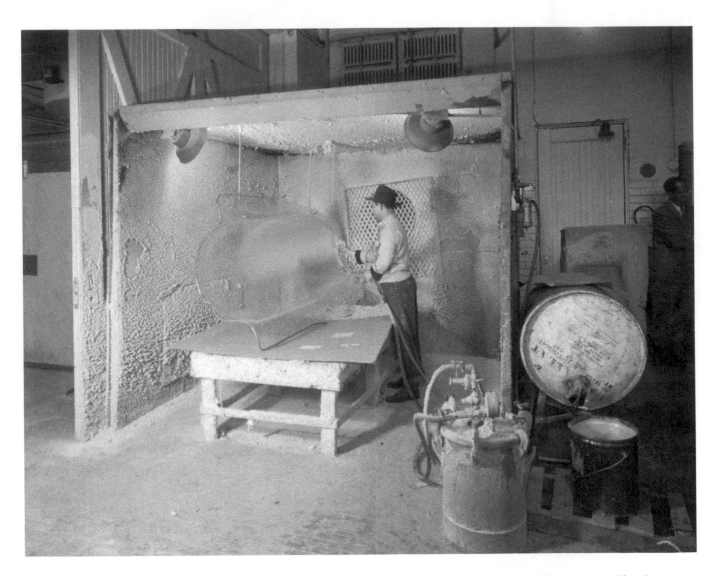

This industrial scene in 1953 shows a worker in the paint shop of the Steiner Plastics Manufacturing Company in Glen Cove. The firm produced canopies for Grumman jets being built for the military in nearby Bethpage, but Steiner was prosecuted for falsifying inspection approvals of a number of the canopies produced that year.

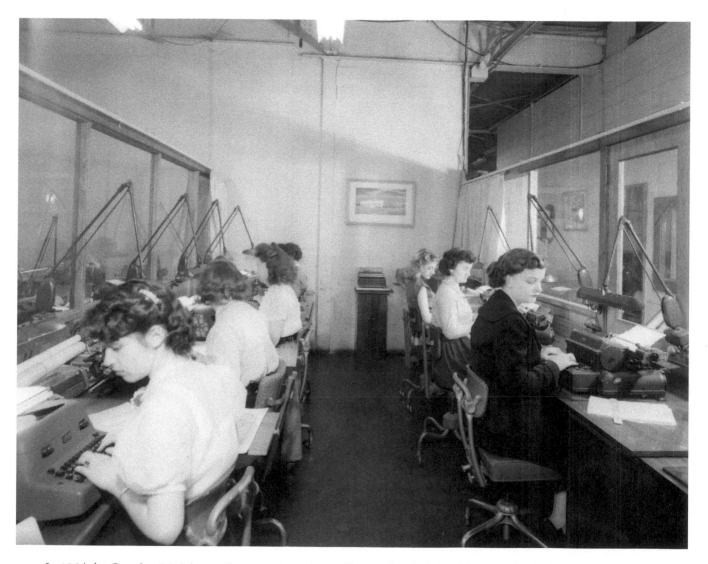

In 1954 the Corydon M. Johnson Company in Bethpage illustrated technical publications for modern industrial designs and provided other graphics-related services. Here the staff typists produce text for publications. Johnson was an air-mail pilot in the 1920s and was originally from Long Island.

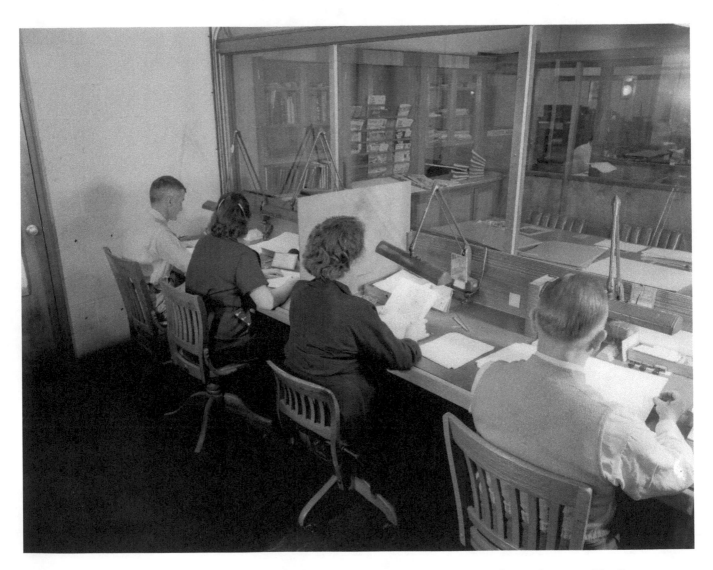

Another group of workers, this one not all female, proofreads materials at the Corydon M. Johnson Company. The firm was very successful and paid its staff a good salary. Johnson's alma mater was the University of Virginia, and he and his wife sponsored a scholarship there for students of high academic standing who also did community service work.

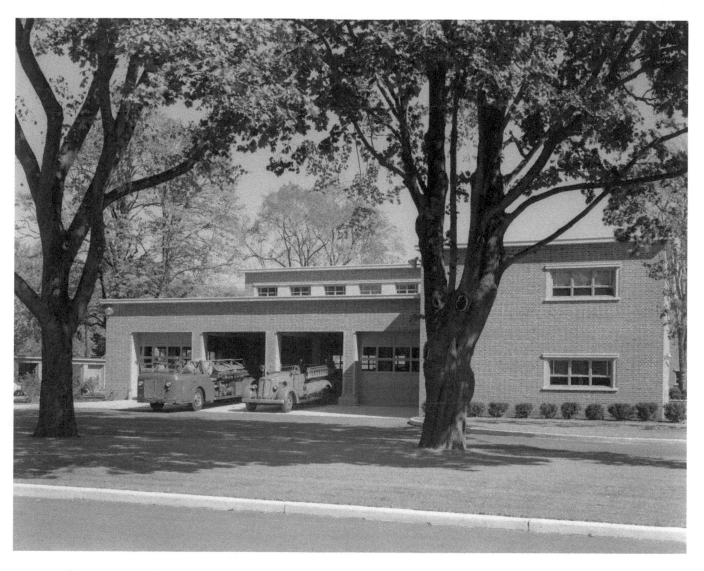

This 1954 image shows the Garden City Fire Department, founded in 1899 as a regular volunteer company with 31 local residents participating. The department was incorporated into the village government in 1920 as part of a real estate deal in which one Alexander T. Stewart promised fire protection for all parcels of land purchased.

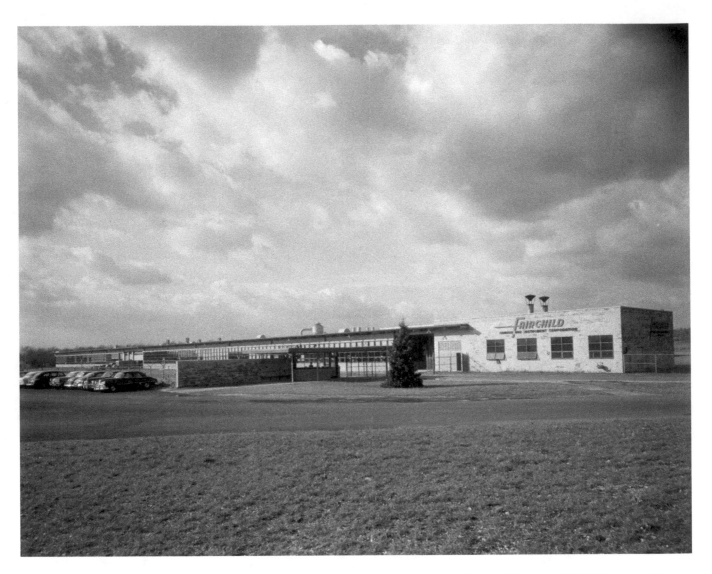

The Fairchild Camera and Instrument Corporation, seen here in 1953, was located in Syosset. Sherman Fairchild pioneered in development of the aerial camera. His many innovations, often on behalf of government agencies such as NASA, included the panoramic reconnaissance camera system and the three-inch mapping camera for the Apollo Project. With his backing, the Fairchild Semiconductor Company was formed in 1957 and would become a leading firm in the 1960s development of Silicon Valley.

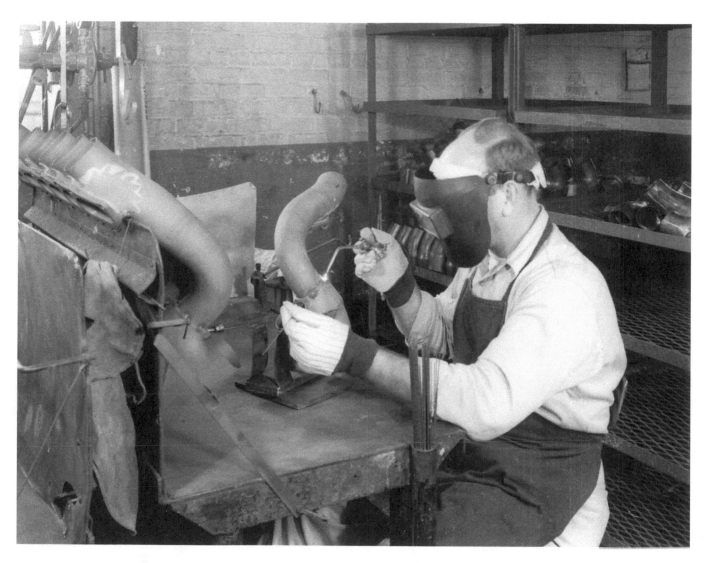

B&H Aircraft was located at 441 Eastern Parkway in Farmingdale. This 1954 image shows a welder sealing a joint on an exhaust manifold. The aircraft firm was one of many drawn to Long Island because of its skilled labor force and wide-open spaces.

As the cold war brought pervasive fears of nuclear attack by the Soviet Union, the Walter Kidde Nuclear Laboratories, located in Garden City, developed fallout shelters. Here in 1955 a young child is shown how to climb down into a Kidde-designed shelter built into a Garden City backyard.

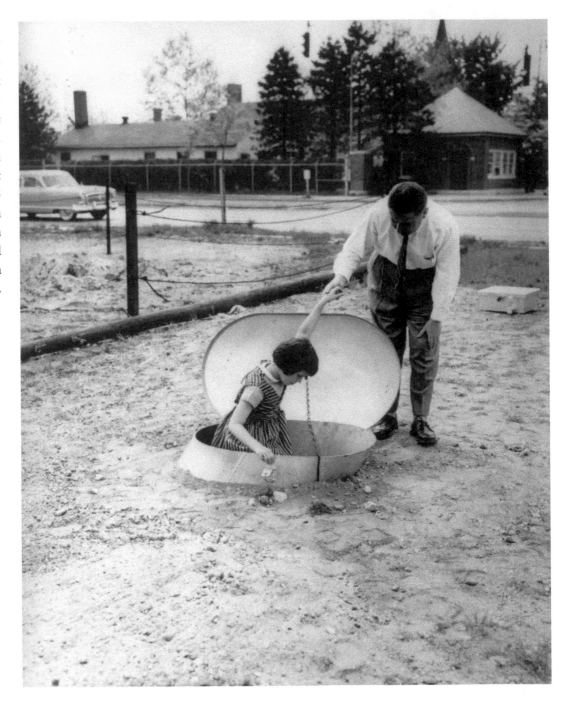

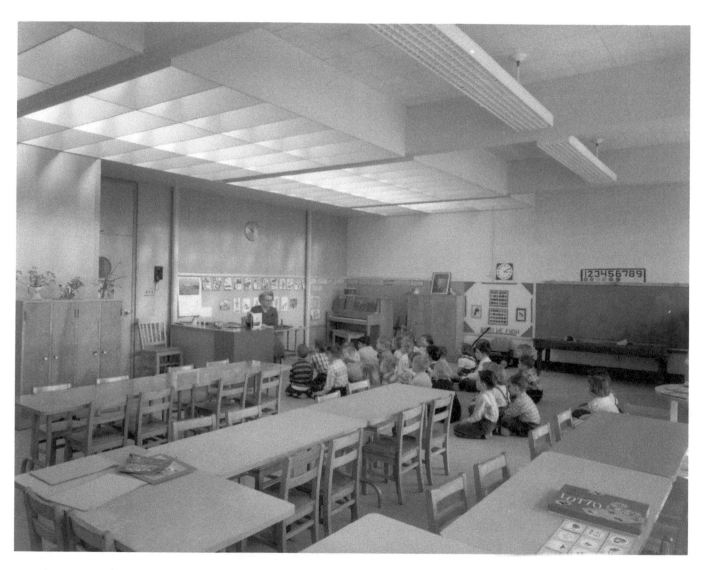

It appears to be story time at the Cherry Lane School at 474 Roslyn Avenue in Carle Place. The town was established by Silas Carle, and its school district was one of the smallest in the state of New York at the time of this 1956 photo.

These men are standing in front of an Adelphi College building in Garden City in 1957. Adelphi was the first college on Long Island, established in 1896 and located in Brooklyn until 1929. Initially coeducational, Adelphi became a school for women after 1912, and during World War II the school focused on nursing. With the advent of the GI Bill, Adelphi reopened its doors to male students.

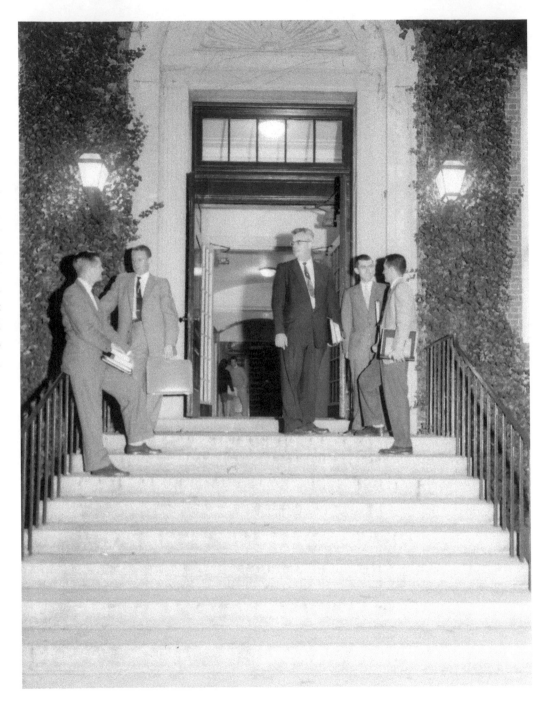

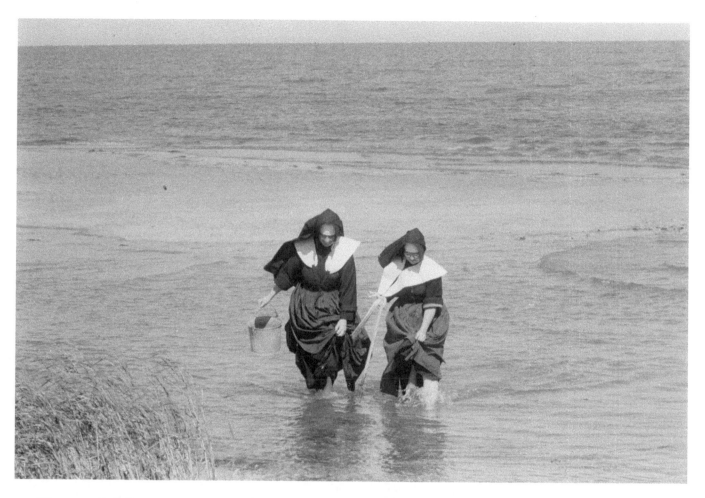

These two Catholic nuns were photographed clamming on a Long Island beach in 1957. Religious communities always found a haven on the Island. The St. Ignatius Jesuit Retreat in Manhassat goes by the name Inisfada, the Gaelic translation of "Long Island." At least two dozen Catholic Retreat Houses were established on Long Island, such as St. Gabriel's in Shelter Island and the Peaceful Dwelling Project in East Hampton. The ocean and peaceful shores provide a good landscape for introspection.

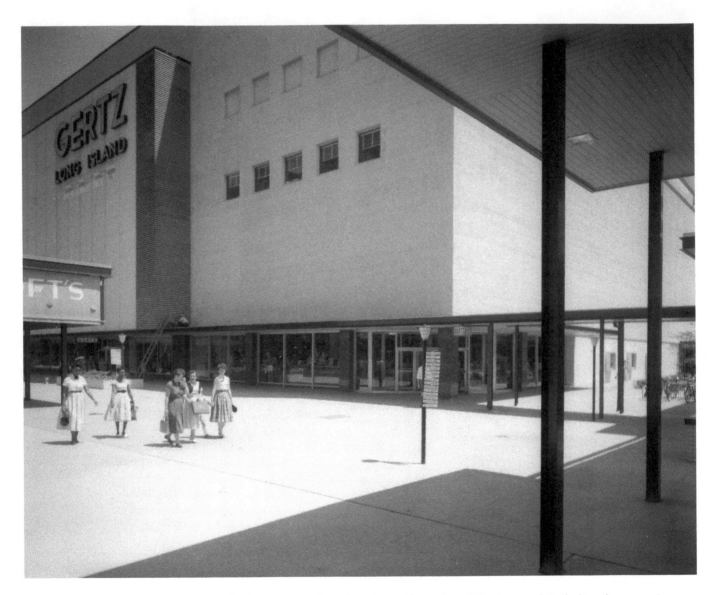

During a three-month period in 1956, the first three modern shopping malls on Long Island opened, including the open-air Mid-Island Plaza (now Broadway Mall) in Hicksville. Seen here in July 1957, Mid-Island had ten stores—including the Gertz department store, a family-owned business based in Queens. At five stories, this particular Gertz store was said to be the tallest suburban department store in America. Gertz eventually operated eight stores on Long Island.

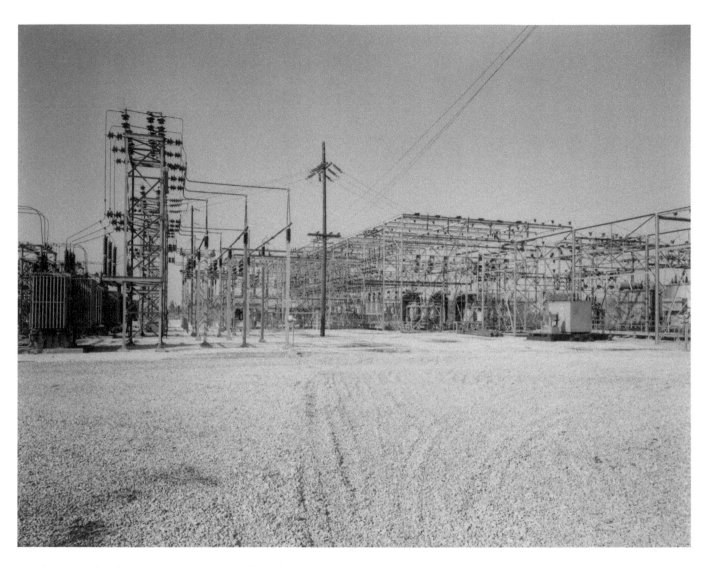

The Long Island Lighting Company was formed in 1911 to supply electric and natural gas power, installation, and servicing for the entire Island. Shown here in 1956 is one of hundreds of substations used to supply electricity to local areas. One can imagine how storms and hurricanes could wreak havoc on these isolated power stations.

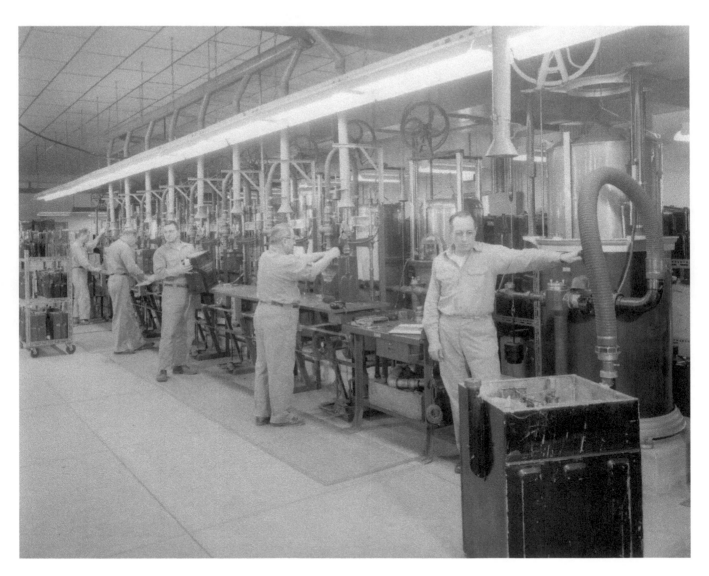

Here in a Long Island Lighting Company plant in Garden City, workers are testing electric and gas meters to be installed in residents' homes, businesses, and industrial sites. In 1957 the company provided the power to run the Island but also supplied economic power by employing thousands of Long Islanders.

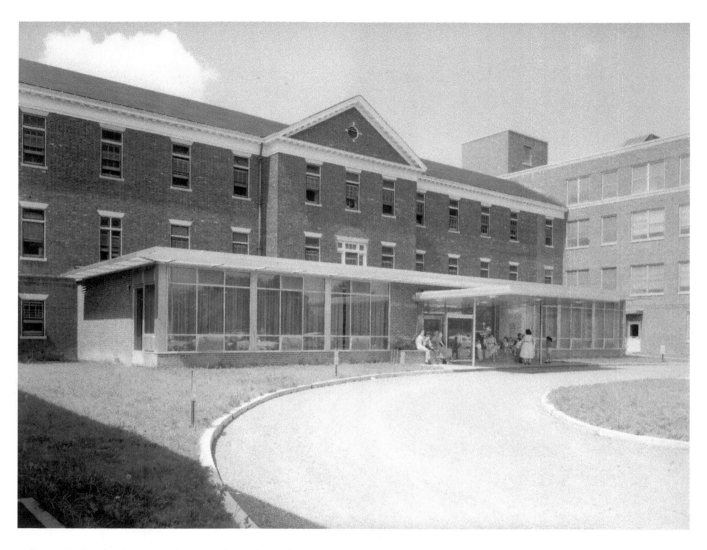

This is the Southside Hospital in Bay Shore, located at 301 East Main Street, in 1956. The oldest and largest community hospital on the Island, it was established in 1913 in Babylon, then moved to Bay Shore in 1919. The facility seen here opened in 1923.

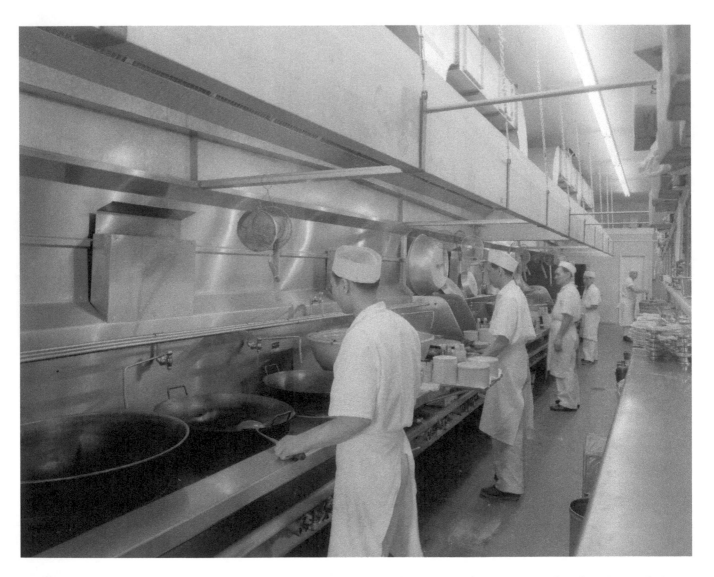

At Gum Wah, a business on Old Country Road in Westbury, workers in the sizable kitchen prepare meals in large iron woks in this 1960 image.

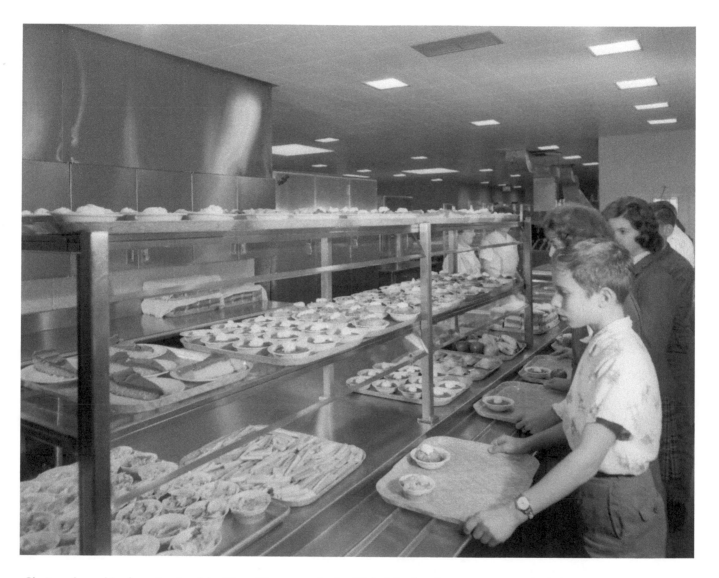

Choices abound in the cafeteria of the Harry Thompson Junior High School in Syosset. By 1961, the baby boom was creating the need for more schools. Thompson was constructed on land donated by Manhattan financier Edward Tinker. The school adopted as its motto the words "Patience, Respect, Integrity, Dignity, Empathy."

Notes on the Photographs

These notes, listed by page number, attempt to include all aspects known of the photographs. Each of the photographs is identified by the page number, photograph's title or description, photographer and collection, archive, and call or box number when applicable. Although every attempt was made to collect all data, in some cases complete data may have been unavailable due to the age and condition of some of the photographs and records.

II **Beach at Rockaway**
Library of Congress
LC-USZ62-100328

VI **Flagpole**
Library of Congress
LC-USZ62-53890

X **Excelsior Hook and Ladder**
Freeport Memorial Library
974.721.D/Volume 1

2 **Shinnecock Indians**
Library of Congress
LC-USZ62-119203

3 **Ground-breaking Ceremony**
Freeport Memorial Library
974.721.D/Volume 1

4 **House in Bay Ridge**
New York State Archives
NYSA_A3045-78_D47_BrY2

5 **Rough Riders at Camp Wickoff**
Library of Congress
LC-USZ62-62101

6 **Old Field Point Light**
Library of Congress
LC-ppmsca-09071

8 **Benson House**
Freeport Memorial Library
974.721.D/Volume 2

9 **Tent City at Rockaway**
Library of Congress
LC-USZ62-77205

10 **Quentin Roosevelt**
Library of Congress
LC-USZ62-61807

11 **Fort Lafayette**
Library of Congress
LC-USZ62-118283

12 **Grove Street Trolley**
Freeport Memorial Library
974.721.D/Volume 2

13 **Oyster Bay**
Library of Congress
LC-USZ62-97438

14 **Motor Launch**
Library of Congress
LC-USZ62-974338

15 **Gathering at Montauk**
Library of Congress
LC-USZ62-116378

16 **Steamboat Dock at Port Jefferson**
Library of Congress
LC-USZ62-117341

17 **Walt Whitman House**
Library of Congress
HABS NY,52-WEHI,1-2

18 **East Hampton Beach**
The Brooklyn Historical Society
v1972.1.395

19 **Garden of Frances Johnston Paris**
Library of Congress
LC-USZ62-94882

20 **Laurelton Hall**
Library of Congress
LC-USZ62-94964

21 **Forest Park**
Library of Congress
LC-USZ62-45754

22 **The Wallace Building**
Freeport Memorial Library
974.721.D/Volume 3

23 **Music Park**
Library of Congress
LC-USZ62-103389

Printed in the USA
CPSIA information can be obtained
at www.ICGtesting.com
JSHW072021140824
68134JS00042B/3735